CATHOLIC ST. LOUIS

A PICTORIAL HISTORY

BY

WILLIAM BARNABY FAHERTY, S.J.

PHOTOGRAPHY BY

MARK SCOTT ABELN

REEDY PRESS
St. Louis, Missouri

Reedy Press
PO Box 5131
St. Louis, MO 63139
www.reedypress.com

Library of Congress Cataloging-in-Publication Data: 2009921679

ISBN: 978-1-933370-83-5

Please visit our website at www.reedypress.com.

Printed in China
09 10 11 12 13 5 4 3 2 1

cover by Rob Staggenborg

Opposite: *St. Roch Church*

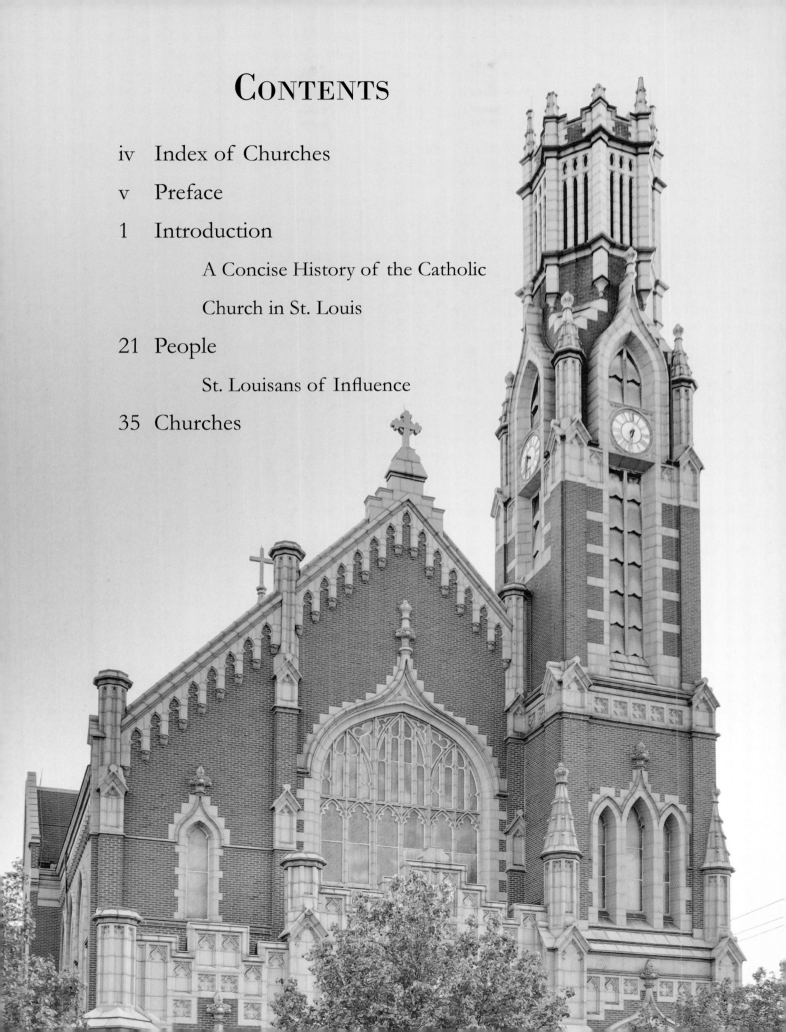

CONTENTS

INDEX OF CHURCHES

PREFACE

The Archdiocese of St. Louis is blessed with its large number of vibrant parishes, a great historical patrimony, and an unapologetic Catholicism that does not fear to proclaim the Faith. This is reflected in her many remarkable churches, some of which are featured in this book. The long and singular history of Catholicism in St. Louis leaves us with vast archives of events and personages, a few of which are displayed within these pages.

A suitable comprehensive photo book of the current churches of the Archdiocese of St. Louis would run at least 2,000 pages, making it unaffordable. Alternatively, featuring only one photo of each church would hardly do justice to any. I must admit that limiting the number of churches to feature in this book was something of a heartache and sorrow, for each church is a "house of God and gate of Heaven" (Genesis 28:17).

Based on this limit, Father Faherty and I selected a small number of churches for this book. We made our selections according to historic significance, artistic expression, fame, and popularity. Some churches in this book are not currently a part of the Archdiocese of St. Louis but are still included for these reasons.

— Mark Scott Abeln, photographer

DEDICATED TO ED AND MARY LOU CODY

Belgian-born Jesuit Peter Verhaegen won a university charter for Saint Louis University in 1832 and arranged for a medical faculty. Courtesy Midwest Jesuit Archives.

In the meantime, the St. Louis College under Father Peter Verhaegen won a university charter in 1832 from the state of Missouri, and promoted medical and law schools during the 1840s.

In that decade, St. Louis had four churches: the Cathedral, St. Patrick's on the North Side at Sixth and Biddle streets, St. Francis Xavier on the university campus at Ninth and Christy, and St. Vincent DePaul on the South Side, a bilingual church with a pastor who spoke German as well as one who spoke English.

Two chapels welcomed German-speaking Catholics: one in the Cathedral Parish, St. Mary of Victories on South Third Street, and St. Joseph's on Eleventh and Biddle. German immigrants came in driblets until 1835. Then they came in great numbers, making St. Louis a binational archdiocese, the only one in the country. All others were predominantly Irish in orientation.

Archbishop Kenrick welcomed the Germans. In letters to mission-help societies in Bavaria and Austria, he rightly claimed that St. Louis was the best place for Catholics and, in turn, best reflected the true Catholic spirit. The Church was triumphant in St. Louis, while barely tolerated in Boston and the East. For Irish Catholics, it was even better than Dublin.

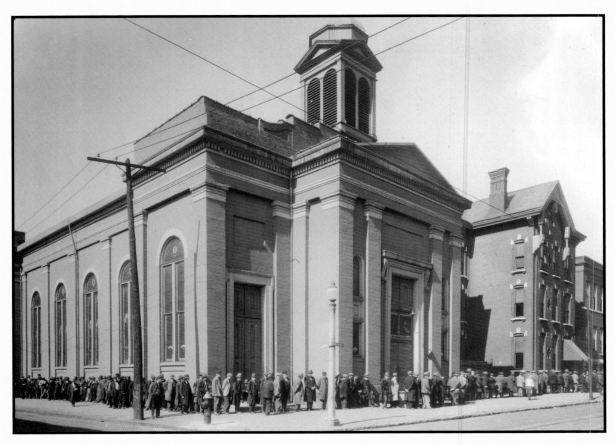

St. Patrick's at Sixth and Biddle streets was dedicated in 1845 and razed in 1973. Father Timothy Dempsey was longtime pastor at St. Patrick's during the early 1900s and was noted for his work with the poor and homeless. Courtesy Library of Congress.

The Germans who came before 1835 were Catholics or Evangelicals. Then in 1838, Lutherans came. German Catholics began Holy Trinity Parish in Soulard and opened the first parochial school in the city. They also began a seminary in the southeast section of Perry County in southeast Missouri. They were to move the seminary to St. Louis in the following decade.

All the while, girls had a choice of academies: Mother Duchesne's Convent of the Sacred Heart; Mother Celestine's school in Carondelet, founded by the Sisters of St. Joseph who had come from France with a state subsidy to teach deaf children; Visitation Academy, which moved to St. Louis from Kaskaskia, Illinois, in the great flood of 1844; and the Academy of the Daughters of Charity. Ursuline Sisters came from Bavaria a few years later, and with a subsidy from King Ludwig I opened an academy at Twelfth and Russell.

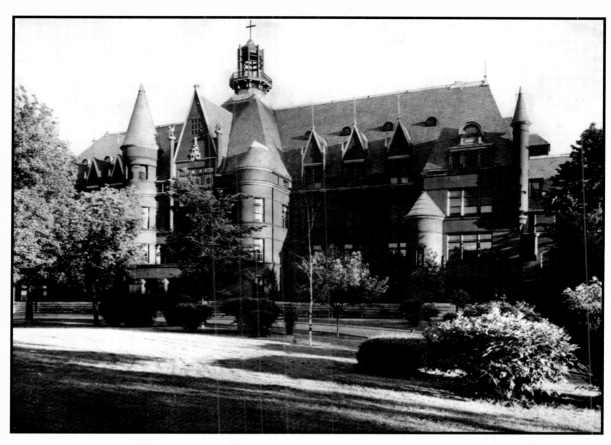

Visitation Academy moved from Kaskaskia to St. Louis in 1844, where it resided at a number of locations, including this chateau on Cabanne Avenue in the first half of the twentieth century. Courtesy Visitation Academy.

Sisters of St. Joseph Convent, 1936. The structure was built in 1841 with reconstruction ten years later.

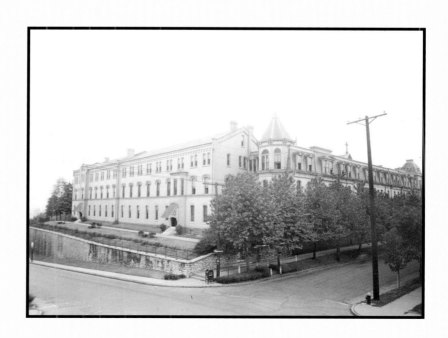

In 1855, a Christian Brother, Patrick Murphy, opened a college on Cerre Street on the near South Side. Vocations to the Brothers' life had great appeal, and many more teachers were available. The Brothers taught at two academies. Archbishop Kenrick obtained permission for the Brothers to teach Latin, and soon they staffed a number of diocesan grade schools. Eventually, the majority of English-speaking priests took basic Latin from the Brothers.

A few years later, parish schools abounded, with the Sisters of St. Joseph and the School Sisters of Notre Dame staffing most of them. Dominican Sisters, Franciscan Sisters, and the Sisters of the Precious Blood of O'Fallon shared this important work over the years.

Cupola at the School Sisters of Notre Dame.

At the same time, a group of nativists, called "Know-Nothings" because they always hid their identity, began to harass immigrants with riots and destruction of property. Father James Henry, pastor of St. Lawrence O'Toole's Parish, gained national fame by defying them.

When German anticlericals came in 1848, the Know-Nothings accepted their support, showing that they opposed Catholic immigrants, not all immigrants.

The Know-Nothings left two sad legacies. They split Irish Catholics and Irish Protestants, who had previously worked together, and forced the Saint Louis College of Medicine to separate, with a loss to both. John O'Fallon, for instance, a Methodist who had built two classical-style buildings for Saint Louis University's medical school, now turned to a new institution, Washington University, and helped with the O'Fallon Technical Institute.

All education had been religious-based until the 1840s. But when the public school system was getting started, it began, unlike European experience, not as auxiliary and helpful to religious education, but as hostile to religous education. Because of this evident hostility, the Presbyterians, who had conducted most of the schools in the country, closed their schools. The Catholics and the Lutherans tried to continue, with the double burden of paying taxes for the

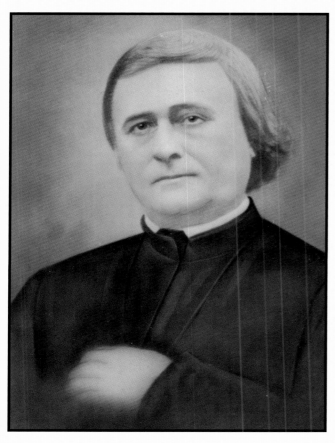

Father Peter DeSmet. Courtesy Midwest Jesuit Archives.

education of all children and paying to have their own children educated as they saw fit.

In the meantime, the missionary Father Peter DeSmet had gone west at the call of the Salish, or "Flathead," Indians, who had sent delegates of Christian Iroquois to St. Louis to get a "blackrobe." He soon organized, promoted, and supplied the missions, although he himself was not a day-to-day missionary. He wrote books about the West and about the experiences of the missionaries that brought many recruits to America and much help for all the missions.

In a sermon at St. Vincent DePaul Church, the Vincentian orator John Timon, later bishop, brought word of a new "hands-on" charitable organization of men started by Blessed Frederick Ozanam in France. At the challenge of Timon, men of Cathedral Parish started the first unit of the Vincent DePaul Society in America, with Father Ambrose Heim as spiritual director and Dr. Moses Linton, physician and educator, as president.

As the nation moved toward civil war, Archbishop Kenrick urged calm, just as Pope Pius IX did in letters to the archbishops of New York and New Orleans. The Missouri State Convention voted to stay in the Union, and dangers from secessionists were checked.

One of the difficult things for Catholics was the oath their priests had to take. One man, Father John Cummings of Louisiana, Missouri, carried his case all the way to the Supreme Court to be allowed to preach. Only a five-four decision approved him, but the case, *Cummings vs. Missouri,* became a landmark in civil liberties.

After the Civil War, the Jesuit educational effort that had been mainly in St. Louis now gave its attention to other places in the Midwest. In 1840, the Jesuits had begun a small school in Cincinnati. After the war, they opened schools in Chicago, Omaha, Milwaukee, and later Detroit. One after another in the midwestern towns there was a Jesuit Catholic school, staffed by priests trained in Florissant.

Hospital clergy came from Bavaria and Austria. Among them were the sisters of Mary of the Third Order of St. Francis, other Franciscans, and after the Civil War, Alexian Brothers from Germany who opened a hospital on South Broadway. Many nuns from St. Louis hospitals died while serving during the yellow fever epidemic in the South. A few years later, when the Franciscan Sisters moved their hospital to the country, Brother Philip Kennedy kept the Alexians in the city.

John Thornton.

The Church moved ahead rapidly in the period immediately after the Civil War, thanks particularly to two individuals, Mayor Bryan Mullanphy and John Thornton. Bryan Mullanphy, son of John, inherited a half million dollars that went to aid immigrants at Mullanphy Emigrant Home, where the father of an emigrant Irish family could stay for a few days until finding work and a permanent place to stay. The Mullanphy Fund lives on in Travelers' Aid.

Thornton made a fortune in merchandising and real estate. Like Mullanphy, he never married, but he gave ten thousand dollars to each of his five nephews and nieces. Fifty percent of the remaining half million dollars went to existing schools, hospitals, and orphanages, such as St. Vincent's German Orphans' Home, opened in response to the cholera epidemic of 1847. The other half went to Archbishop Kenrick for a revolving fund to lend to parishes at low rates of interest and with no foreclosure date. Eighteen parishes used Thornton loans.

In 1870, Archbishop Kenrick went to Europe to attend the Vatican Council. He found the meetings unsatisfactory. He saw no convincing argument in Scripture or tradition for a unilateral declaration of Papal infallibility.

Archbishop John J. Kain.

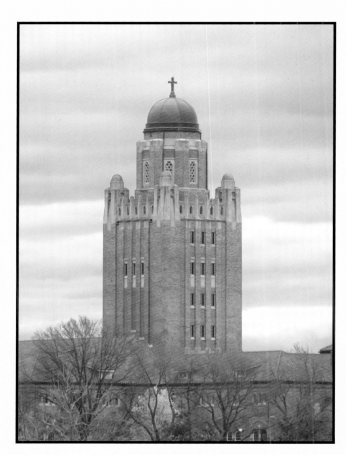

Glennon College in Shrewsbury.

Nonetheless, the proposal passed. Kenrick withdrew before the end of the session and, under pressure from Rome, limited his activities for the next fourteen years. He left most of the day-to-day running of the archdiocese in the hands of capable Coadjutor Patrick Ryan. When Ryan became archbishop of Philadelphia in 1884, Kenrick resumed full charge.

Kenrick continued to welcome immigrants. He blessed the first parish of Bohemians in America, St. John Nepomocene's parish. It was to grow to great importance by the turn of the century, thanks to the leadership of Monsignor Joseph Hessoun and Hynek Dostal, editor of *The Voice*, a magazine that went to all the Bohemians in the United States.

Polish immigrants eventually opened five parishes, beginning with St. Stanislaus Kostka in 1884. A Maronite congregation opened St. Raymond's; Slovaks, Slovenes, and Lithuanians were few, but welcomed. All the while, Irish and German parishes continued to serve their people. The Irish-German Archdiocese that began as the best effort of the French in America had become multinational and gained strength from all its constituents.

Sixty bishops and archbishops came to St. Louis to honor Kenrick on his fiftieth jubilee as a bishop on December 1, 1891. Father Francis Goller, intellectual leader of the German Catholic community, praised Kenrick as the Father of Immi-

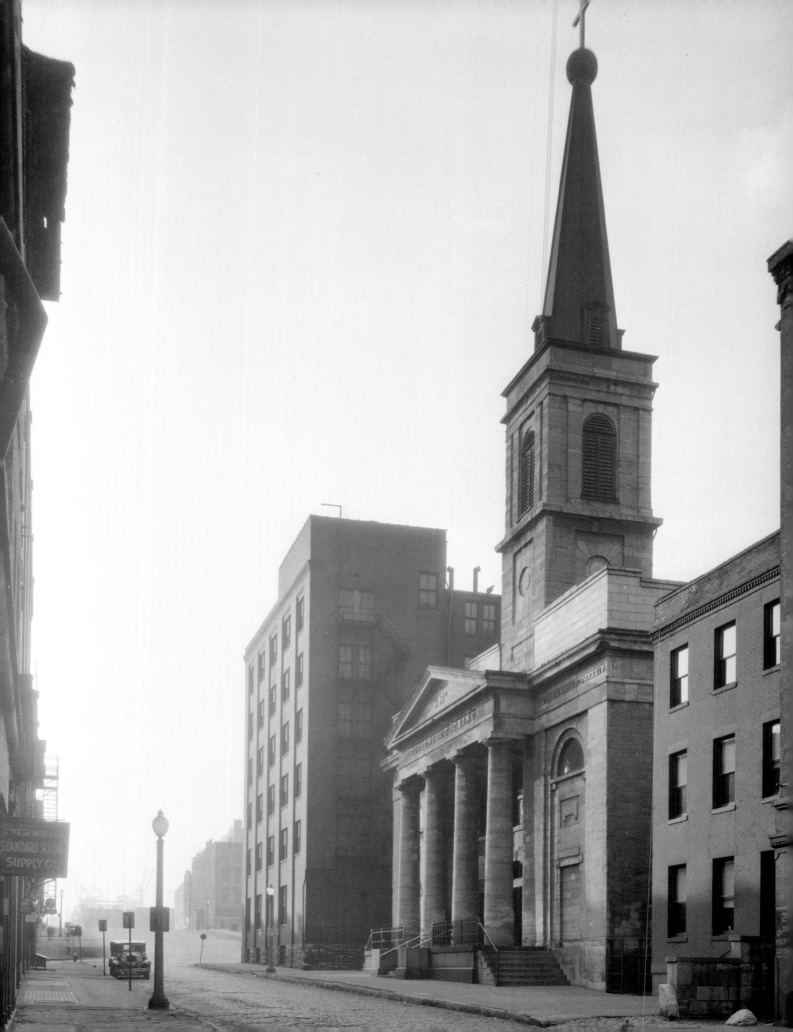

grants. The procession that went by Archbishop Kenrick's home on his jubilee took two hours.

Kenrick's policy of gradual Americanization kept thousands in the Church, unlike St. Paul, Minnesota's Archbishop John Ireland's policy of immediate Americanization, which eventually lost the Church several hundred thousand Uniates. Kenrick's late years, however, brought misunderstanding. He opposed the first large labor union, the Knights of Labor. He recommended as his successor a young priest, a good man but of limited capacity, who did not meet the approval of his fellow St. Louis clergy.

Roman authorities then named Bishop John J. Kain of Wheeling as archbishop, but they did not notify Kenrick, and the transition lacked grace. The new archbishop's first action was to condemn the *Western Watchman*, the most successful Catholic paper of the time. Father David Phelan, an astute editor, answered in a humorous way. Kain had to back down.

In 1896, a tornado hit the city, leveling St. Francis de Sales and Annunciation, and damaging Holy Trinity Church.

On the positive side, Archbishop Kain did come to the rescue of the Christian Brothers, who suffered from a decision that restricted their work to elementary school education. Kain also promoted a Eucharistic Congress.

In 1901, Pope Leo XIII named Bishop John J. Glennon, auxiliary bishop of Kansas City, as coadjutor in St. Louis. Two years later, at Kain's death, Glennon became archbishop.

At that time, the city of St. Louis hosted the greatest of World's Fairs, with all countries but Russia participating. The Pope sent a delegate, Archbishop Joseph Satolli. The archdiocese began a new cathedral and followed over the years with Kenrick

World's Fair President David R. Francis, front right, and Cardinal John J. Glennon, front third from right, welcome Archbishop Joseph Satolli to the 1904 World's Fair. Courtesy Library of Congress. Opposite: View from the southeast of the Basilica of St. Louis, King of France, 1934. Courtesy Library of Congress.

Seminary and a junior seminary that bore Glennon's name.

Unusually tall, with a fine voice, splendid presence, and a poetic strain of presentation, Archbishop Glennon, as the successor to Archbishop Patrick Ryan, soon became recognized as the leading pulpit orator of the time. The St. Louis archbishop gave the funeral sermon for Cardinal James Gibbons, the tribute to New York's St. Patrick's Cathedral on its anniversary, and the main address at the Eucharistic Congress in Dublin in 1932 on the fifteen hundredth anniversary of the arrival of St. Patrick.

Saint Louis University had fallen back during the last half of the previous century, while Christian Brothers College surged in public esteem, only to be set back by a disastrous fire in 1916. Saint Louis University took new life under the leadership of William Banks Rogers as president. He affiliated a medical school and authorized a school of law. He gathered a council of laymen to advise on public policy, and he involved the university in the 1904 World's Fair.

At the conclusion of Rogers' term as president, Saint Louis University marked time until the 1920s, when it took renewed vitality with the leadership of

William Banks Rogers.
Courtesy Midwest Jesuit Archives.

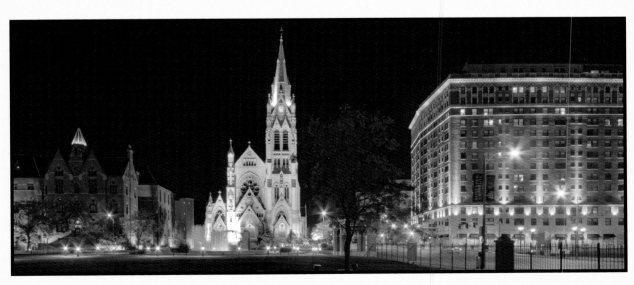

Saint Louis University, DuBourg Hall at left, St. Francis Xavier center, and Jesuit Hall at right.

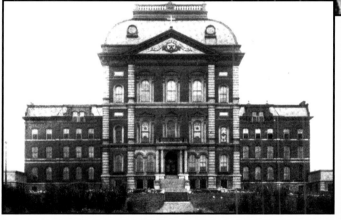

The Christian Brothers flourished at their Cote Brilliante location from 1882 to 1916, until a fire struck. Courtesy CBC.

Fathers James Macelwane and Alphonse Schwitalla. A "Corporate College" plan united all Catholic colleges under the mantle of Saint Louis University, so that students at Webster, Maryville, and the community colleges received Saint Louis University degrees and shared intermural activities.

On the parish level, a major change took place. New parishes no longer had a one-nationality congregation. In the southwest section of the city, with Irish St. James to the north, Italian St. Ambrose to the northeast, and German Holy Family to the east, Epiphany began as a multinational parish.

On the high school level, the archdiocese opened Rosati-Kain, taught by two sisterhoods, Josephites and Notre Dames. Marianists began McBride High School on North Kingshighway and South Side Catholic on Grand at Delor.

Earlier schools, such as CBC and Loretto and Ursuline Academies, moved to new sites. Three Jesuit high schools combined in a new building on Oakland Avenue near Kingshighway.

A newly ordained Jesuit, Daniel A. Lord, was named national promoter of the Sodality of Our Lady. Taking advantage of the growth of Catholic high schools, he geared his promotion chiefly on the high school level. He and his associates edited a popular monthly, *The Queen's Work*, published pamphlets, and began leadership schools that took place during the summer in every section of the country.

By this time, forty-five dioceses and nine ecclesiastical provinces had been carved out of territory served by Bishop Joseph Rosati in 1826. No area in the long history of the Church matched this record.

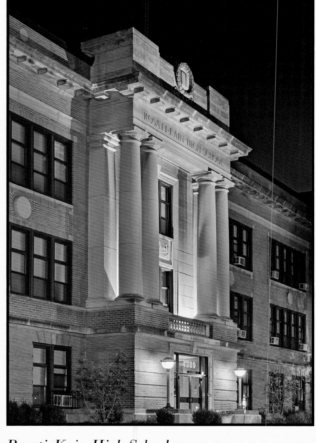

Rosati-Kain High School.

Just as Archbishop Glennon gave little attention to the status of the working man, and opposed women's suffrage as well as labor unions, he seemed unconcerned with the plight of Blacks. Once, Blacks were predominantly Catholic from French days. An influx of unskilled workers during World War I created a new situation. Glennon left this ministry to a small team of Jesuits at St. Elizabeth's Church on Pine Street. This apostolate, in turn, did not prove a major aspect of Jesuit zeal, but an area left to a few dedicated men.

After a stirring talk by University Professor Claude Heithaus, S.J., Saint Louis University welcomed African American students and faculty in the fall of 1944. Saint Louis University High School integrated in 1946, the year that Pope Pius XII named Glennon a cardinal of the Church. The new cardinal stopped in Ireland on his return and died there. His funeral procession moved under an arch intended to honor the new cardinal on his return.

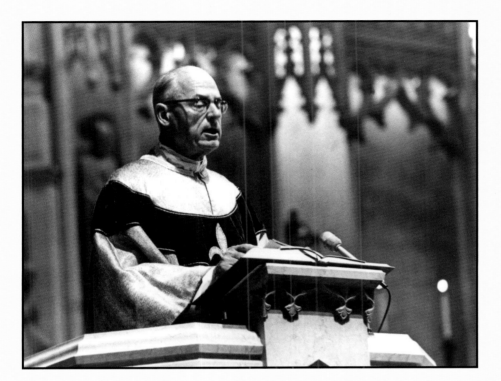

Claude Heithaus, S.J., called for racial integration in a sermon on February 11, 1944, at a student mass, Saint Louis University.

Through a long summer, St. Louis Catholics looked for a new archbishop. Finally, Archbishop Joseph Elmer Ritter arrived in St. Louis, while Cardinal fans were cheering their heroes' victory over the Red Sox in the World Series of 1946. The appointment of Ritter was a complete surprise.

Archbishop Ritter moved against segregation by pointing out that all people who lived in a parish should be welcome and their children should go to the school of the parish where they lived. Some parents in the northwest parishes of the city protested. They took the position that Cardinal Glennon had held, that the state forbade integration. When it was pointed out that one was excommunicated automatically by taking his bishop before a lay court when he exercised his office, opposition faded.

Cardinal Ritter established several coed high schools, a departure from previous policies in the archdiocese, among them DuBourg on the southwest side, Rosary in Bellefontaine Neighbors, Laboure in the northwest sections of the city, Mercy in University City, and Aquinas in Florissant. He began an archdiocesan missionary team in La Paz, Bolivia.

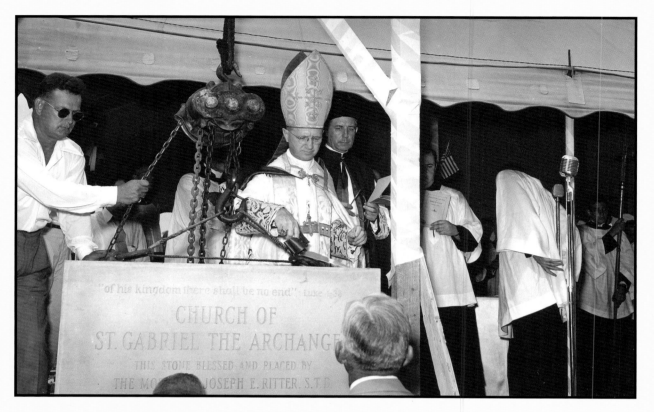

Archbishop Joseph Ritter dedicates the cornerstone to St. Gabriel the Archangel Church on October 28, 1951.

Shortly before he called the Second Vatican Council, Pope John XXIII named Ritter a cardinal. At the Council, Ritter advocated religious freedom, the exercise of collegiality, the cooperating of the bishops with the Pope in guiding the Church, updating the liturgy and the lay apostolate, widening Scripture readings, and giving attention to Scripture in the religious life of the average Catholic.

Unfortunately, Cardinal Ritter died shortly after returning from Rome, and his successor, Cardinal John J. Carberry, had no plans for introducing the wise recommendations of the Council. He pleased the few traditionalists, who abhorred change, even when an ecumenical council of their Church had advocated it. After twelve uneventful years, he offered his resignation. Pope John Paul II accepted it.

In 1980, St. Louis welcomed Bishop John May of Mobile, a Chicagoan by birth. Archbishop May stated that he had read the history of the archdiocese and the city and moved with sure steps. He began a discussion and action program called "Renew." It had a good effort, but came a bit late.

The bishops of the nation chose Archbishop May as president of the Council of Bishops. It was a great tribute to him personally and to the archdiocese.

With his prodding, Rome chose two auxiliary bishops for St. Louis: Edward O'Donnell of the archdiocese and Terry Steib, provincial superior of the Divine Word Fathers. The Hosannas from choirs of many North Side churches filled the Cathedral and reflected the great advance in recognition of equality of races in the Church. Bishop Steib was a Black orator. It was fifty years since Archbishop Ritter united the people. St. Louis Catholics still had far to go. But they moved steadily on the high road.

Cardinal John Carberry.

Archbishop John May.

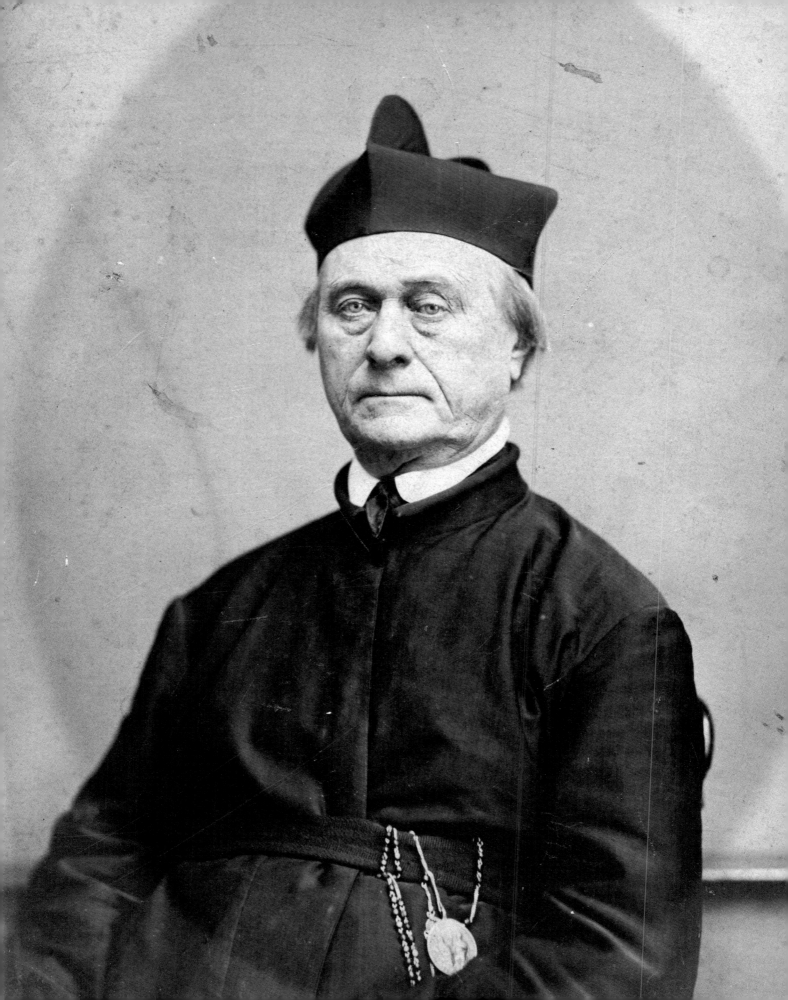

THE URSULINES

Ursuline Academy at Twelfth and Russell.

When Vicar General Joseph Melcher went to Europe in 1846 to recruit personnel for the Church in St. Louis, he met an Ursuline nun, Mother Magdalen Stehlin, at a convent near Vienna. She wanted to begin an institution of her order in the "wilds of America."

On his return to America, Father Melcher told Archbishop Kenrick of the possibility of securing Ursuline nuns from Europe. The archbishop heartily approved, and Father Melcher passed on his word of welcome. Two other nuns from the Austrian convent accompanied Mother Magdalen. On the way to America, they visited an Ursuline community at Landshut in Bavaria, gaining one novice and the promise of help from the sisters.

Archbishop Kenrick welcomed them on September 5, 1848. They enjoyed the hospitality of the Visitation Sisters for two months. Then, the Ursulines moved into a small residence and opened a school. Seven nuns from Landshut enlarged the community. They brought $960 in donations with them. The Bavarian Mission Society, the Ludwig Mission Verein, and a union of all Bavarian mission help societies under the sponsorship of King Ludwig I of Bavaria promised support. The king personally gave four thousand dollars to purchase land for a new convent. Over the next seventeen years, the Ursulines would receive sums averaging six hundred dollars a year from the Ludwig Mission Verein.

The archdiocese purchased a plot of ground at Twelfth and Russell. Architect Francis Saler planned and built the new convent, the first Ursuline Academy in America. The nuns soon paid all their bills. They later opened an academy in Arcadia, Missouri, and moved their St. Louis Academy to suburban Glendale.

ARCHBISHOP PETER RICHARD KENRICK

SHEPHERD OF MID-AMERICA

Dublin-born Peter Richard Kenrick, a graduate of Maynooth, the leading seminary in English-speaking lands, was ordained a priest in March 1832, at the age of twenty-six. He was teaching seminarians in Dublin a year later, when his brother, Bishop Francis Patrick Kenrick of Philadelphia, asked him to come to America. This he did in 1833. Though a scholar by inclination, he succeeded in various aspects of Church ministry.

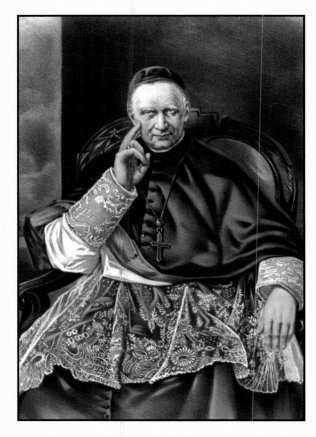

In 1841, Bishop Joseph Rosati of St. Louis sought his assistance. Pope Gregory XVI appointed Kenrick coadjutor bishop of St. Louis. When Rosati died two years later, Kenrick succeeded him.

Mayor John Darby described the new bishop as "a learned and finished scholar . . . a man of great erudition, pious, modest and unobtrusive, meek and unostentatious in manner, he seems to have devoted himself to his sacred and holy calling with a singleness and steadiness of purpose that few men have ever surpassed." He became archbishop in 1847. Historian Thomas Scharf called him "one of the most distinguished prelates of the American Church, a learned theologian, an able administrator, and a man of greatest generosity and benevolence." Like Rosati, he gained recognition as one of the outstanding bishops in Christendom.

Newcomers from Europe came to recognize Kenrick as the Father of Immigrants. He understood their varied backgrounds and accepted their diverse languages. He encouraged gradual Americanization. He wanted bishops who spoke German in those areas where many German Catholics lived, such as Quincy, Illinois. Archbishop Kenrick also showed his great concern for the poor in St. Louis, immigrant and native, by encouraging young Father Ambrose Heim, who started

and successfully ran a "People's Bank." To increase the number of people using this forerunner of the modern credit union, the archbishop moved Father Heim to the Cathedral and opened membership to all the city's people. After Father Heim's premature death, Kenrick ran the day-to-day affairs of the highly successful bank.

As an advocate of peace, Kenrick became concerned as hostilities began to grow. While a slave state, Missouri had so many nonslave economic interests that the state was neither secessionist nor abolitionist.

Military forces of the seceding states fired on Fort Sumter in April 1861. Lincoln called for volunteers to save the Union. Since the War Between the States was for a political goal, the saving of the Union, Kenrick called for peace—as Pope Pius IX recommended in letters to the archbishops of New York and New Orleans.

When Pope Pius IX called the Vatican Council in 1870, Kenrick opposed a unilateral declaration of papal infallibility. He saw no compelling argument in Scripture or tradition. Hounded by Roman authorities, he left the business of the archdiocese to Auxiliary Bishop Patrick Ryan. In 1884, Ryan became archbishop of Philadelphia. and Kenrick resumed control. When he celebrated his fiftieth jubilee as a bishop, the first in American experience, the commemorative procession took two hours to pass his home—a gift of a grateful people.

JOHN BAPTIST DUERINCK

Botanist John Baptist Duerinck arrived in Missouri in 1834 and taught at Saint Louis University and St. Joseph College in Bardstown, Kentucky. Later, he became procurator at St. Mary's Mission in Kansas. He sent wildflowers to the famous herbarium at Leipzig. Shortly after, the Leipzig Herbarium became part of the Missouri Botanical Garden in St. Louis. There, Professor John Dwyer of Saint Louis University studied and named Duerinck's flowers.

As a result of a flatboat accident on the Missouri River near Kansas City, Duerinck drowned in 1857 at the age of forty-eight.

THE EMIL FREI FAMILY

EXPERTS IN ART GLASS

Emil Frei, Sr.

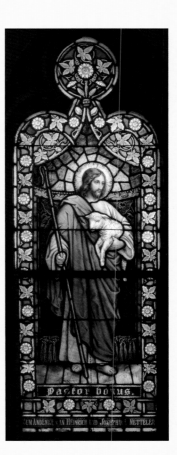

A native of Bavaria and an expert in art glass, Emil Frei accepted an invitation to come to St. Louis in the late 1800s. He set up a studio at 3934 South Grand Boulevard.

The Emil Frei Company soon became famous for beautiful stained glass windows. Frei received many commissions and won a grand prize at the 1904 Louisiana Purchase Exposition in St. Louis. By 1909, the company employed fifteen artists and nine glass blowers in studios in Munich and St. Louis, and by 1911 had adorned two hundred new churches from New York to San Francisco with figure windows. Frei claimed rightly that the work was equal in every respect to the best imported work. His wife, Emma Mueller Frei, an immigrant from Heidelberg, assisted him at varying times as secretary, treasurer, and vice president.

As his father gradually retired, Emil Frei, Jr., took up and continued with many St. Louis churches. Over the years, Emil

Emil Frei, Jr.

Frei, Jr., studied the blue of the Chartres Cathedral in France. He entered the building before dawn and watched the effect of the growing sunlight. In his late years, he specialized in one dominating color, usually blue. Among his best works are the transepts in St. Francis Xavier College Church. When the visitor looks at those windows, he gazes in awe as he would were he visiting Chartres, Rheims, Cologne, or any of the great cathedrals of Europe.

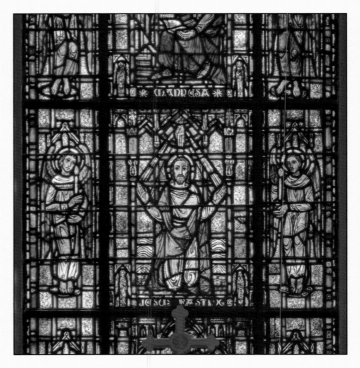

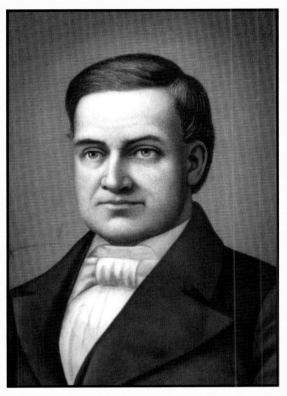

John Mullanphy, a native of Ireland, amassed wealth in merchandising and real estate and aided many Catholic enterprises. John's son, Bryan, later became mayor of St. Louis and left more than a half million dollars to aid Irish immigrants.

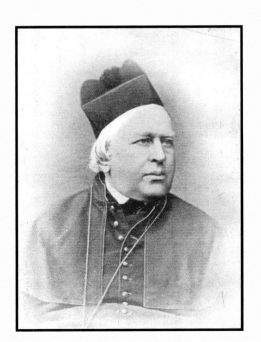

Joseph Melcher, a native of Vienna, educated in Italy, vicar general of the Archdiocese of St. Louis, recruited priests and nuns for St. Louis and became bishop of Green Bay, Wisconsin.

Louis St. Ange de Bellerive, Commandant of French mid-America, turned over land east of the Mississippi River to the British in 1765 and moved to St. Louis, making it the governmental center of Upper Louisiana. (Captain William McKnight photo)

CHURCHES

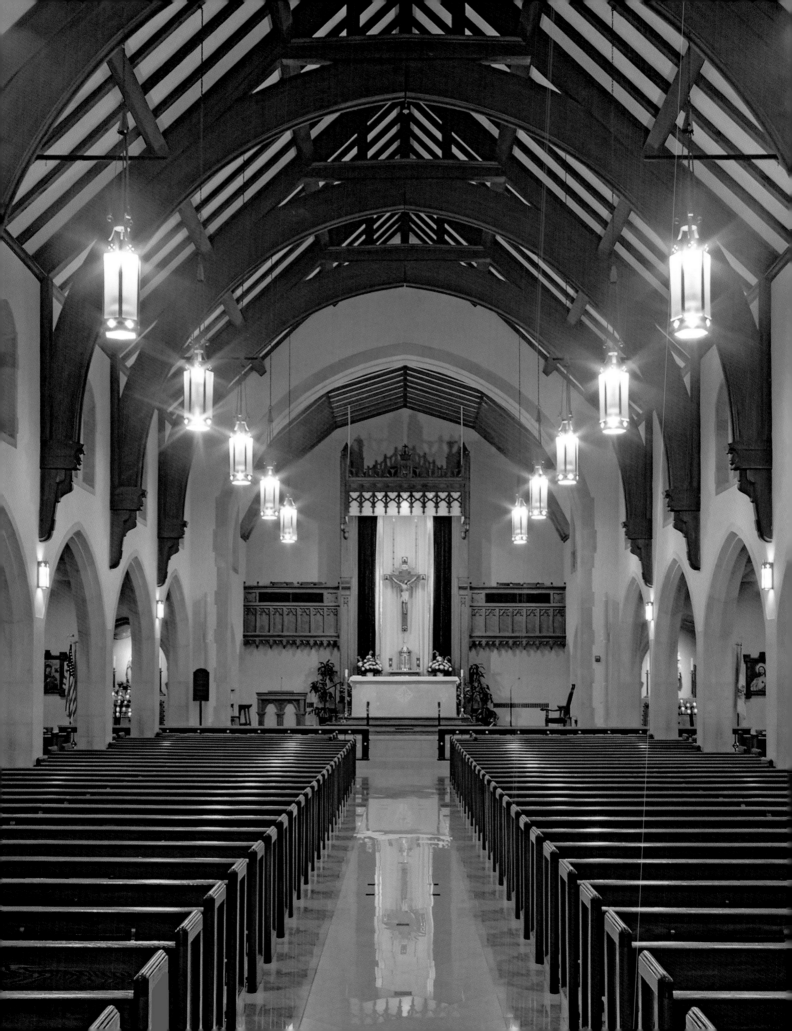

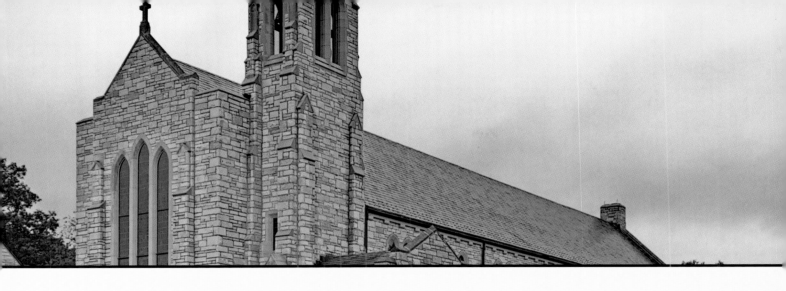

ALL SOULS

In the period after World War II, several churches tried new architectural patterns. All Souls in Overland, however, chose traditional English Gothic in 1950 during the pastorate of Father Walter J. Tucker. Architects A. F. and Arthur Stauder designed the church using Indiana limestone. A sixty-eight-foot tower adjoins the west front. The structure supplanted a frame church, blessed by Father John S. Long, pastor of All Saints, who organized the All Souls congregation in 1908.

As population moved out from the city, the main ways north and northwest moved around Overland so that few people see All Souls in the ordinary course of travel.

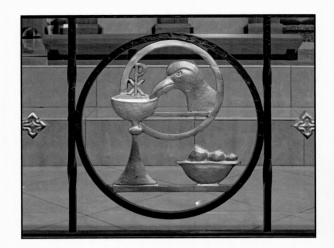

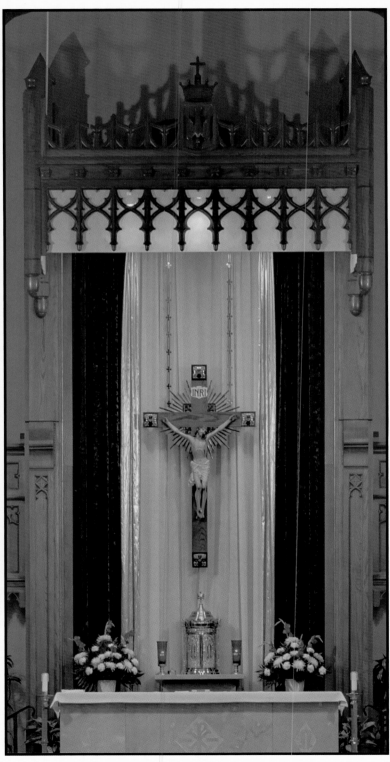

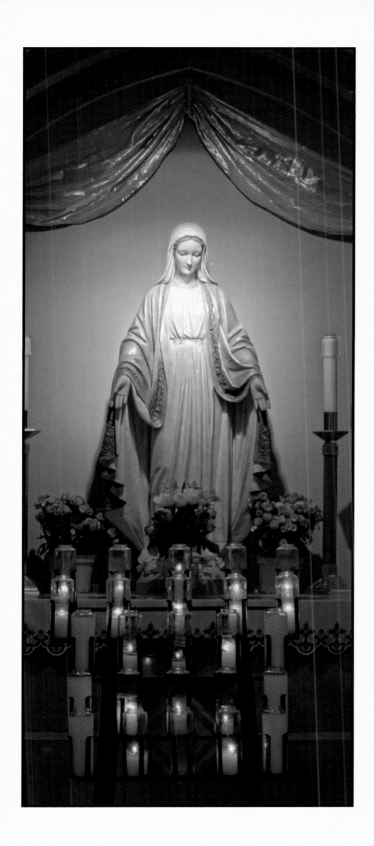
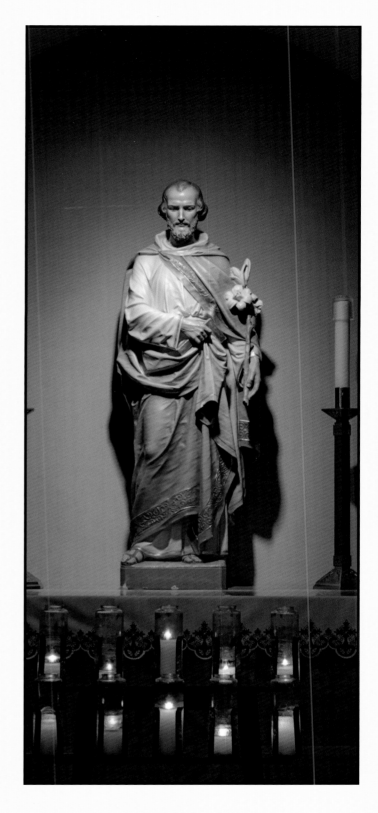

Opposite top left: *Eucharistic symbols on altar rail include the pelican, which according to legend sacrificed itself to feed its dying chicks.* Opposite lower left: *Infant Jesus of Prague.* Opposite right: *High altar.* Above: *Altars of the Blessed Virgin Mary and St. Joseph, parents of Jesus.*

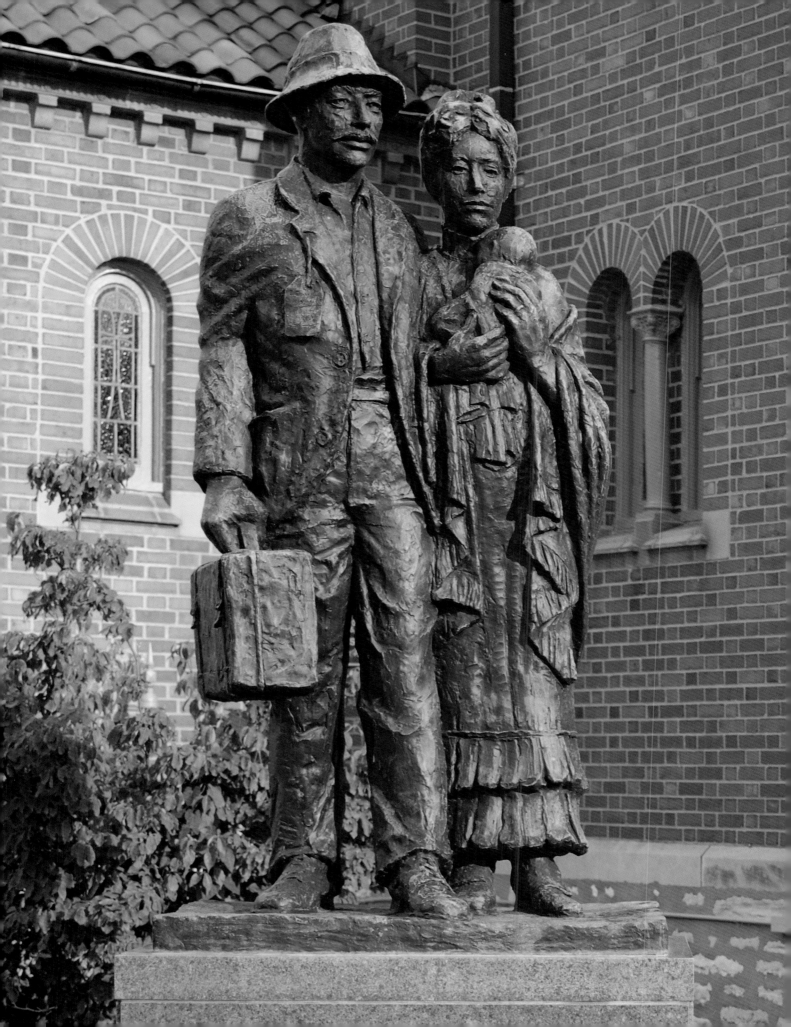

ST. AMBROSE

In 1923, Father Julius Giovanni became pastor of St. Ambrose on the Hill and planned a church of Toledo Romanesque style. The cornerstone was blessed in 1925, and the parish flourished. A statue of immigrants in front of the church gives the area a sense of permanence.

Immigrants from near Milan in Northern Italy settled in the area to labor in the clay pits. When World War I came, a surprising number of young men from the area joined the Navy and Marines. The Hill—as the enclave in South St. Louis is called—out-ranks all urban neighborhoods in the country in stability of population.

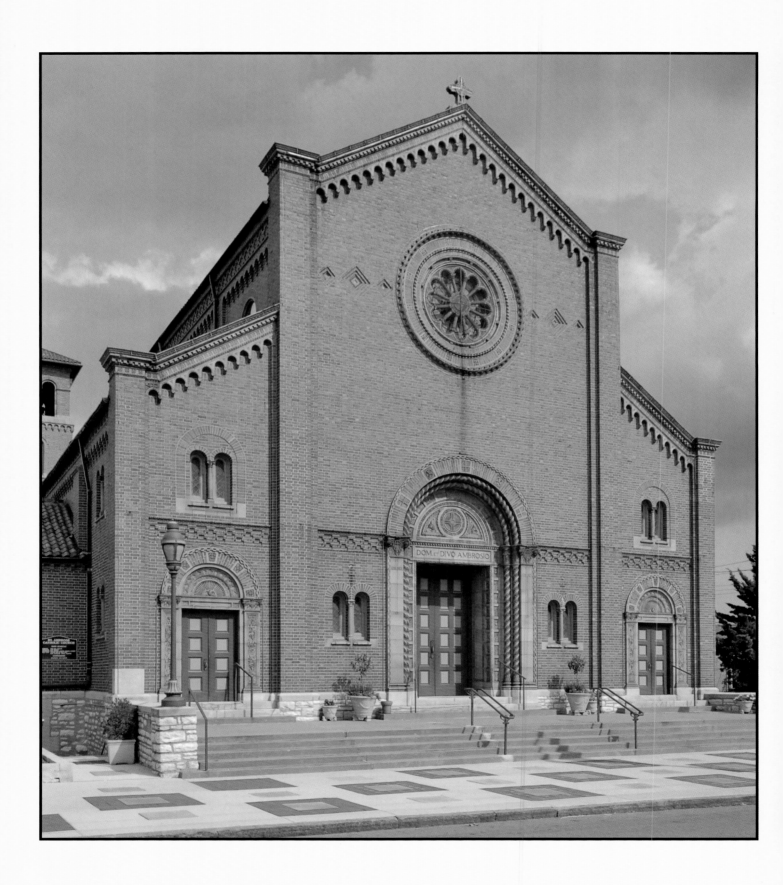

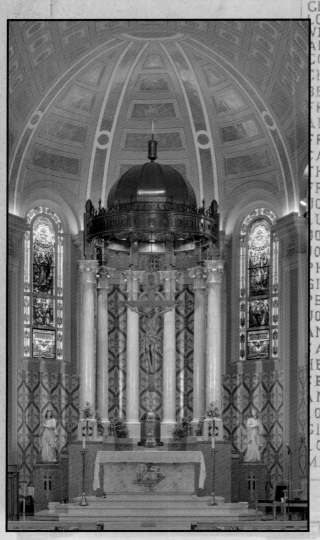

BENEFATTORI DELLA CHIESA

GIUSEPPE & ANGELINA BENTIVEGNA	REV. RAYMOND F. DIERMAN
LORENZO-MARIA & JOHN MARTORANA	RT. REV. JOHN H. SMITH
VENERANDO & ANTONINA TORRISI	VINCENT - ANN CIPOLLA
ANGELO & ADELE PURICELLI	ROBERTO-ERNESTA AIROLD
COSMO - ELSIE GIUDICI	MATTEO-CATHERINE SCIUT
CHERUBINO - ANNA GRIMI	PAOLO-DESOLINA CRESPI
BEN - GIUSEPPA - JOSEPH BERRA	JOE·MARIA·JOSIE SORBELL
FRED - MARY FRANCESCHI - SONS	PAUL J.- MARY TORNO
ALPHONSE - RACHEL MIGNECO	JAMES - MARY RAUTENSTRA
FRANK - NETTA PISANI	HAROLD - JENNIE RHODUS
CARMELO - VINCENZINA MARINO	CAESAR M.-FLORENCE RE
THERESA-JOSIE-TONY CANTONI	LOUIS-ROSE LAMPERTI
FRANK - ASSUNTA FERRARIO	LOUIS - JULIA FRIGERIO
JOHN - LUCY BRUSATTI	JOHN - JOANNA PISANI
LUIGI - ASSUNTA PONCIROLI	PETE - JO, CELESTE FASANI
JOSEPH - PAULINE MANIACI	C.M.J.-DEBBIE BAZZETTA
JOSEPH - ROSA CAMPISE	MARCO-MARIA GRIFFERO
PHILIP - LOUISE CANTONI	MARCO-PATRICIA GRIFFERO
GIUSEPPE - ANNA PELLITTERI	MARIO-LOUISA CHIODINI
PETER - LENA MANTOVANI	EDOARDO - LENA IMO
JOHN PISANI - FAMILY	JOHN B.-THERESA COLOMBO
ANTHONY - ANGELINE VENEGONI	BART-ROSE ANN SARACINO
CAESAR - LENA CANTONI	NICK - ROSE LAFATA
HENRY P. RUGGERI JR.	JOHN M.- ANNA M. BERRA
CESARE PURICELLI	DAVID - SERENA FONTANA
ANGELO-GIOVANINA PASTORI	JOSEPH - SALLY DeGREGORI
LOUIS-JOSEPHINE AIAZZI	ANTONIO - LOUISA NOE
GIUSEPPE ROSSI	AMBROSE - CAROLINE NOE
LOUIS PASTORI	ANGELO MARIO & ANNA COGNASS
MICHAEL - NETTIE RUGGERI	PETER - MARIETTA TORRET

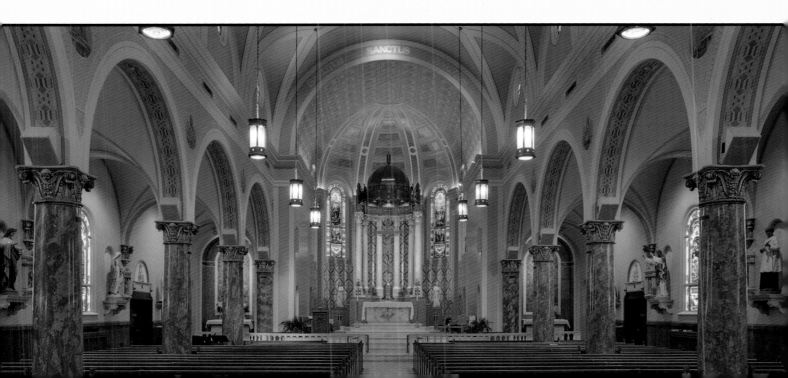

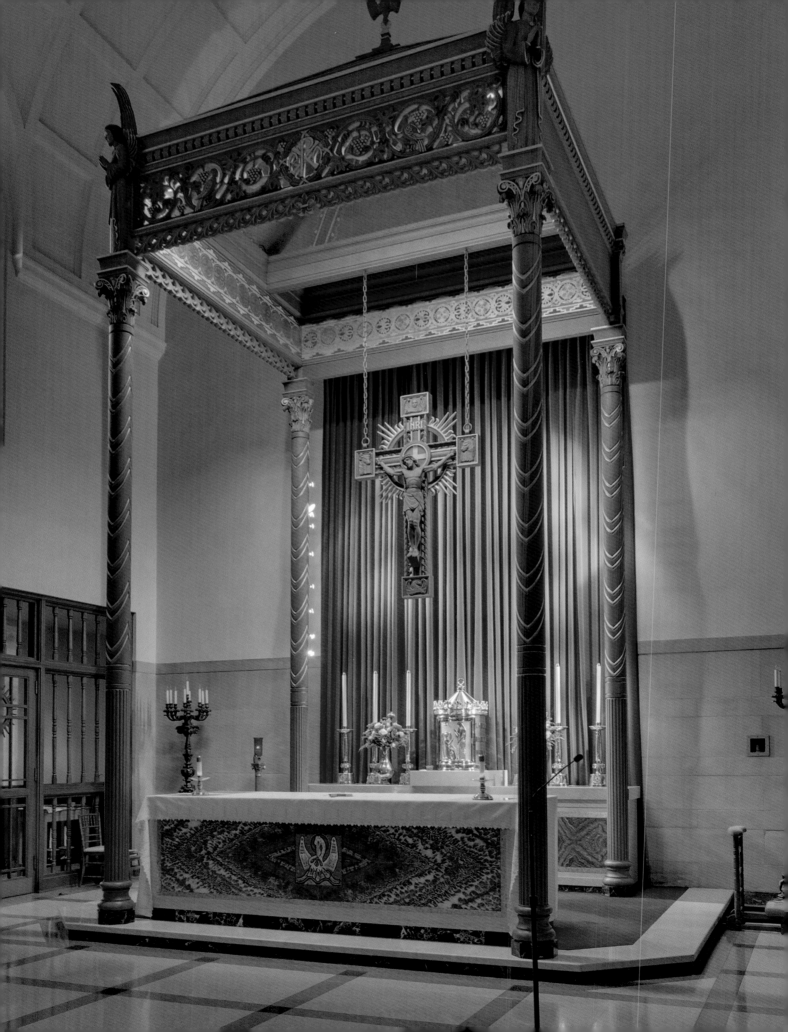

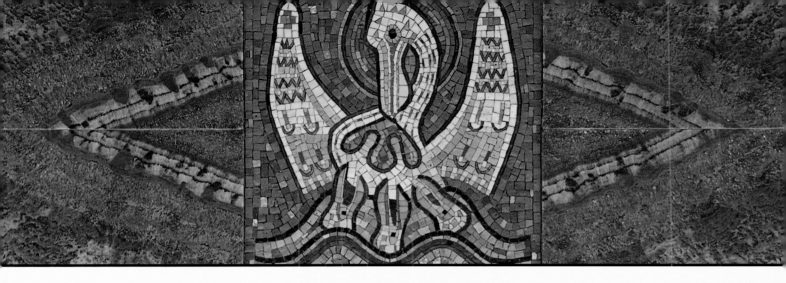

ANNUNZIATA

Father Charleville Faris planned Annunziata, an attractive church of Gothic design on the north side of Clayton Boulevard, west of Immaculata.

Second-generation St. Louisans tended to spoke out from their ancestral parishes: Sts. Peter and Paul to St. Aloysius, Holy Family to Epiphany, and St. Francis de Sales to Seven Holy Founders. So the Cathedral and St. Francis Xavier saw their sons and daughters move out Clayton Road to Immaculata or Annunziata.

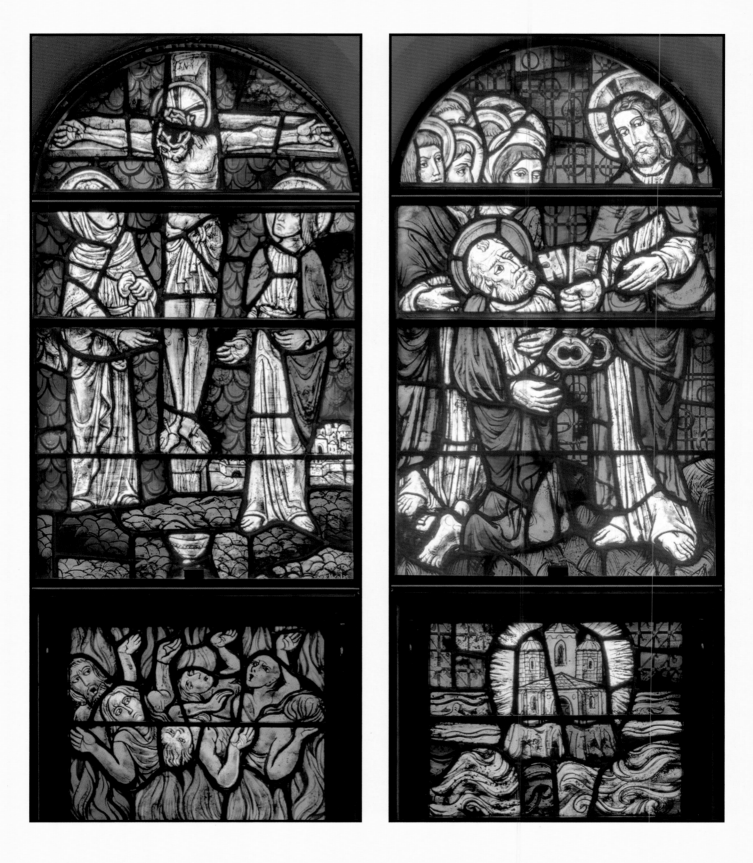

Above: *Stained glass windows of the Crucifixion of Christ, and St. Peter receiving the Keys of the Kingdom.* **Opposite upper right:** *Door is surmounted by Episcopal arms.*

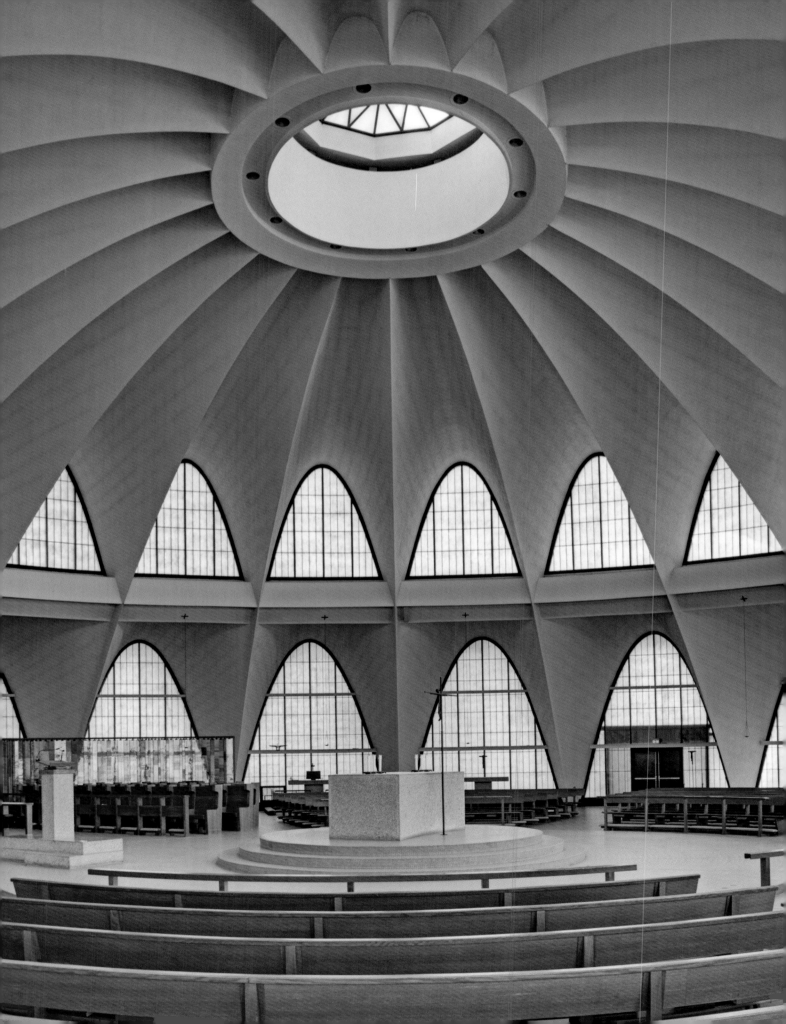

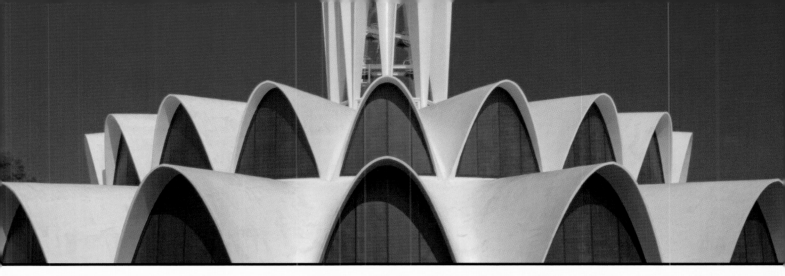

ST. ANSELM

The St. Louis Abbey, St. Anselm, a most awe-inspiring circular church, consists of two sets of concrete curving shells on two levels, set in twenty identical bays tapering to the center. Above the shell is a thirty-foot bell tower of concrete. Gyo Obata of Hellmuth, Obata and Kassebaum was the principal architect in charge of design. The church was dedicated in 1962. No pillar obstructs one's view, offering a sense of infinity. Like the Arch on the waterfront, St. Anselm will never be duplicated.

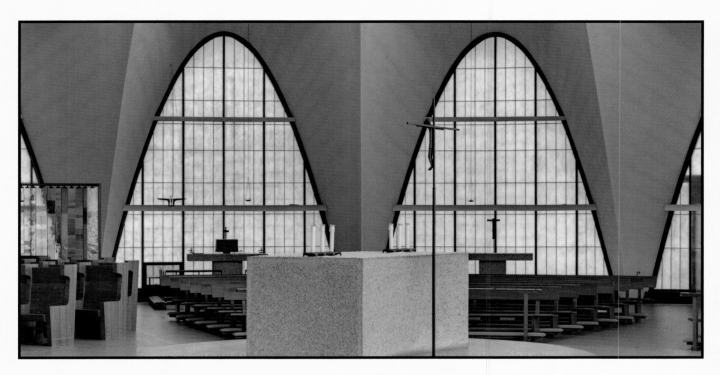

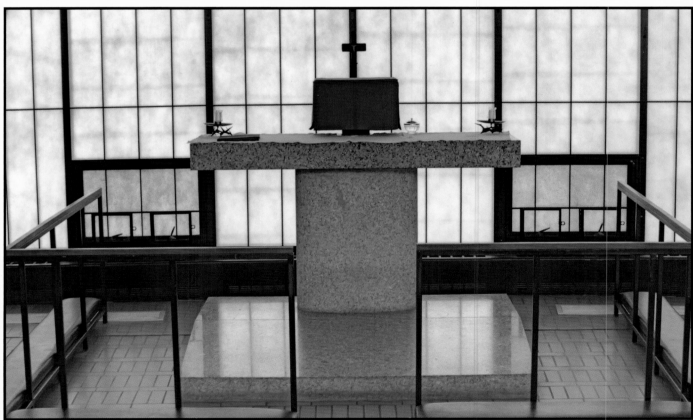

Top: *The altar is placed in the center of the church.* Lower: *Blessed Sacrament is reserved in the tabernacle.* Opposite: *Fourteenth-century statue of the Madonna and Christ Child.*

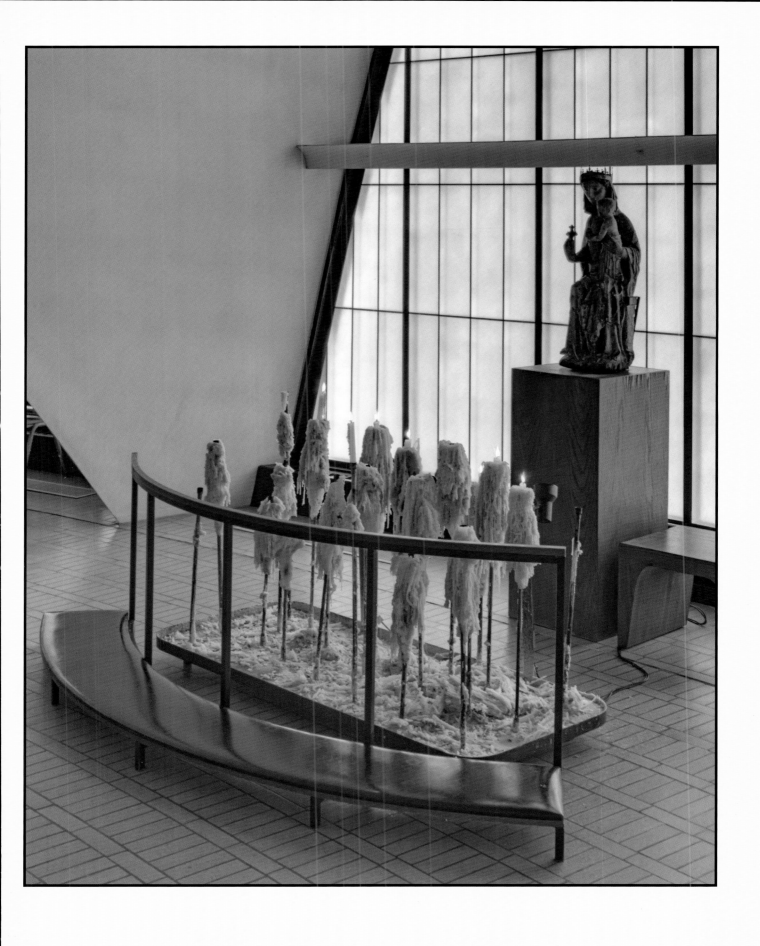

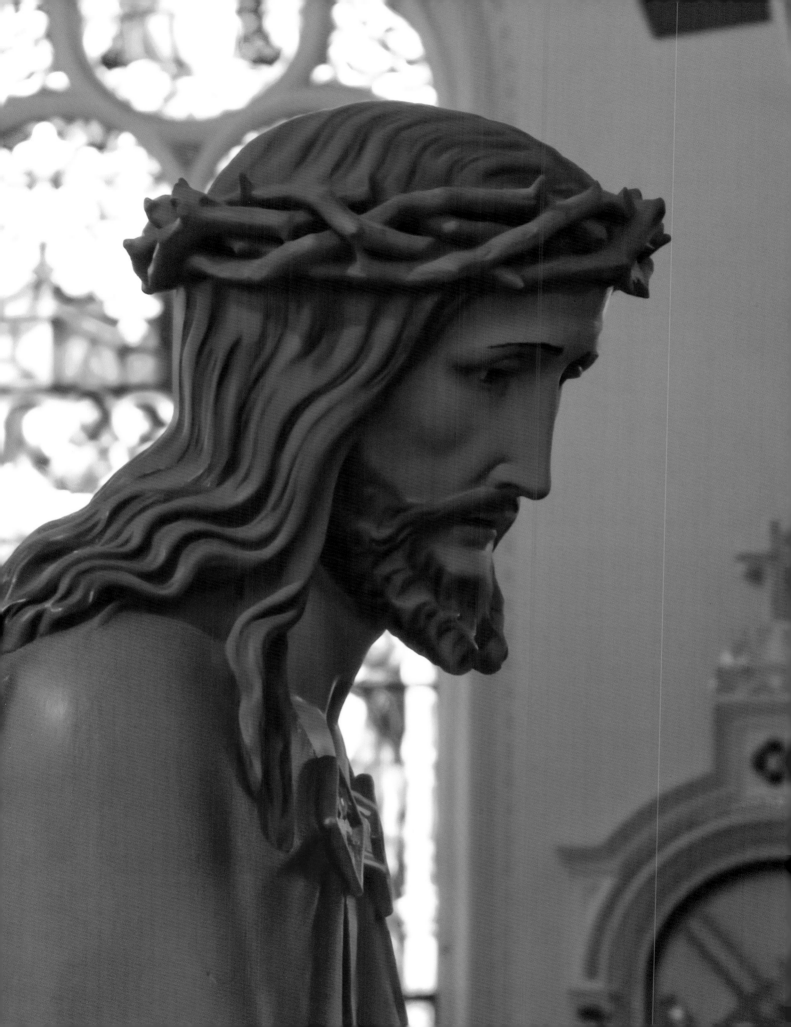

ST. ANTHONY
OF PADUA

Father Servatius Altmicks, O.F.M., opened a friary in 1862 and a church on the South Side in 1869. A Franciscan brother, Adrian Wewer, designed the church of Romanesque style, and Brother Anselm Wolff decorated it. Paintings of the four Doctors of the Western Church and four Franciscan saints adorn the walls. A fire damaged the roof early in the new millennium, but repairs followed immediately.

Perched on a ridge that dominates the area before it, St. Anthony with the twin towers faces north and looks over the homes of immigrants from the Rhineland.

Opposite: *Jesus as the Man of Sorrows.*

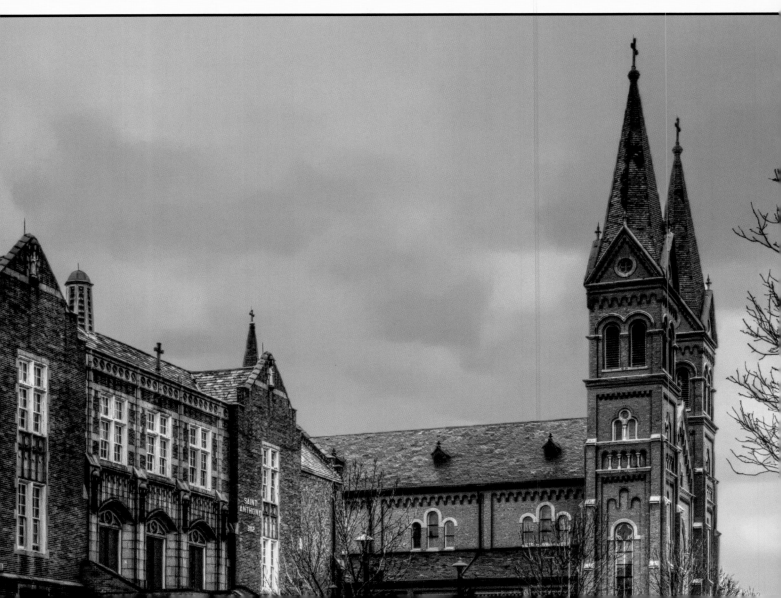

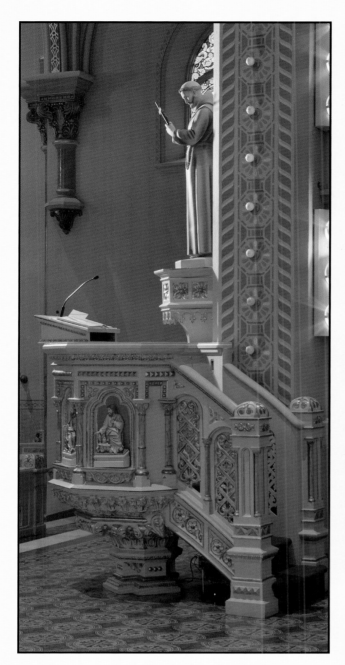

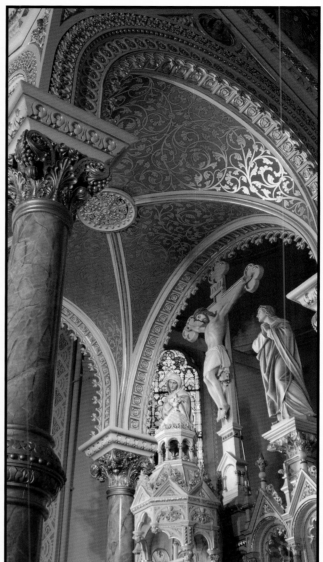

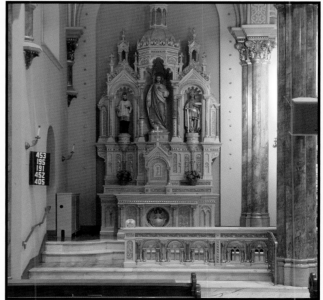

Opposite Top: *A view of the church from the Compton Hill water tower.* Above: *Pulpit under statue of St. Francis of Assisi.* Top Right: *The Blessed Virgin Mary and St. John the Apostle flank the crucifix under the baldachin.* Bottom Right: *Altar of the Sacred Heart of Jesus.*

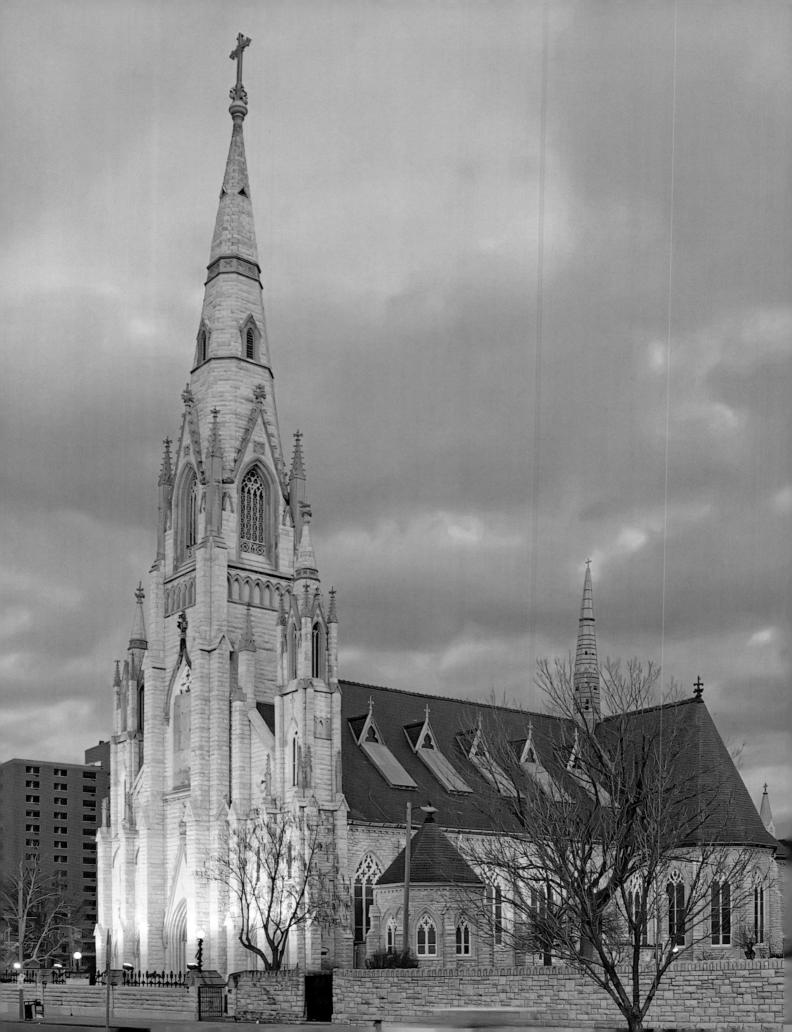

St. Alphonsus Ligouri, the "Rock Church"

St. Alphonsus Ligouri Church, of English Gothic style facing west on Grand Avenue, was blessed by Coadjutor Archbishop Patrick Ryan in 1872 in what was then open country. In 1875, it became the center of a newly created Western Province of the Redemptorists. In 1893, its missionary status ended with the establishment of parish boundaries. A fire damaged it in 2007, but restoration began immediately.

St. Alphonsus answered many needs of the people: It was a pioneer parish in the Central West End; a revival center for a wide area; and is presently a home for black Catholics moving into the area.

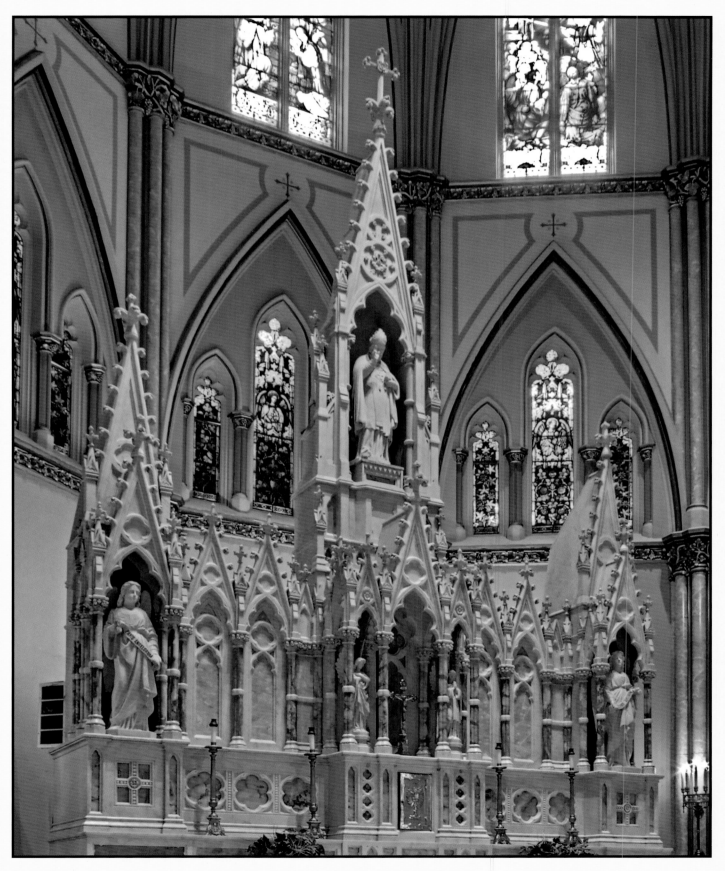

Above: *Detail of high altar.* Opposite Left: *Shrine of Our Mother of Perpetual Hope.* Opposite Right: *South side aisle.*

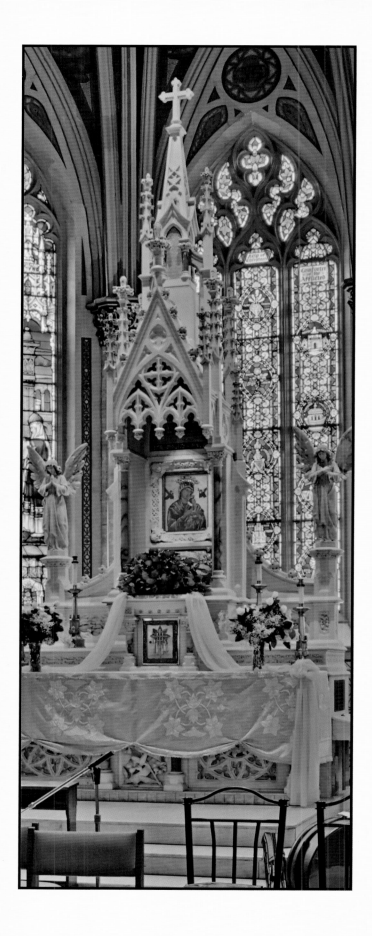
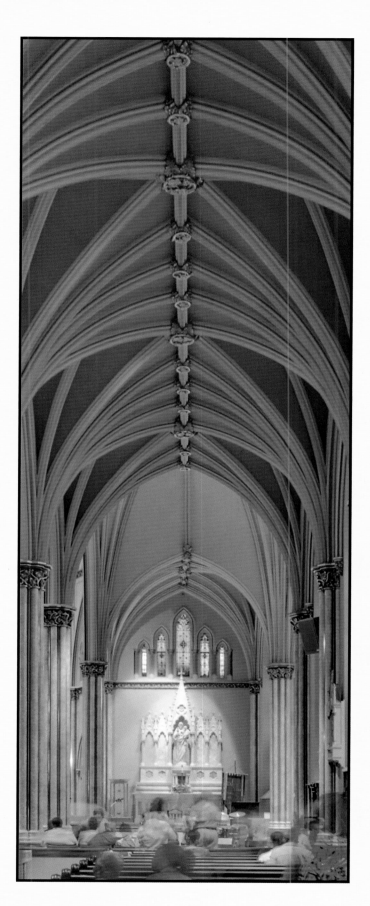

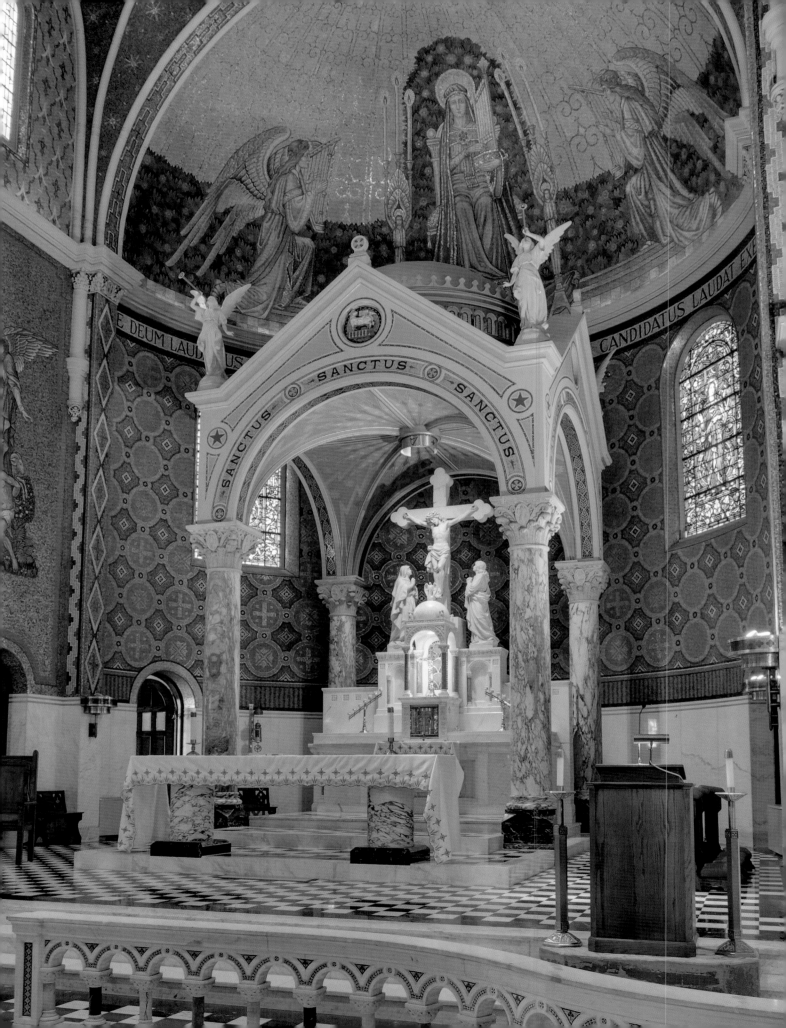

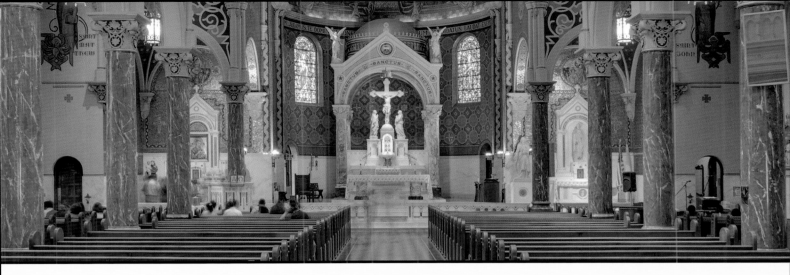

St. Cecilia

Father Bernard J. Benton organized St. Cecilia near Carondelet Park in 1906. A new church of Romanesque style, designed by H. R. Hess, was dedicated by Archbishop John J. Glennon in 1927.

A fine selection of mosaics adorn its walls. Two unmatched towers face east toward the Mississippi seven blocks away. The parish is bilingual, offering Spanish-language services. St. Cecilia boasts the only parish credit union in the archdiocese.

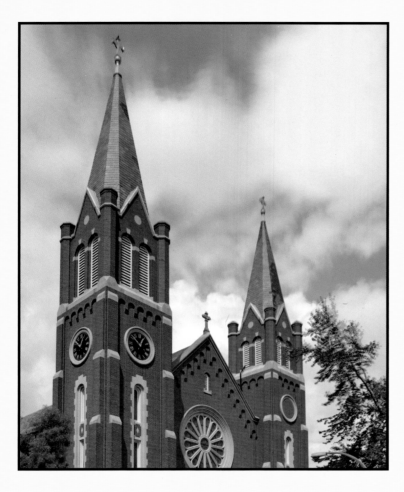
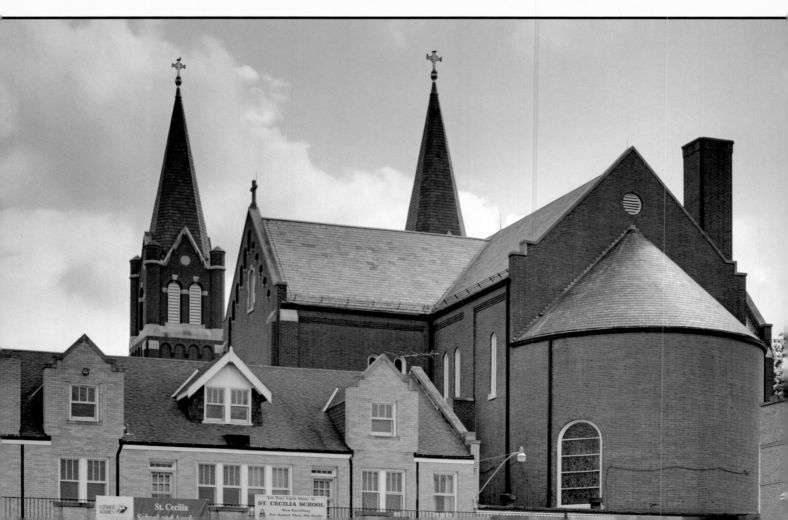

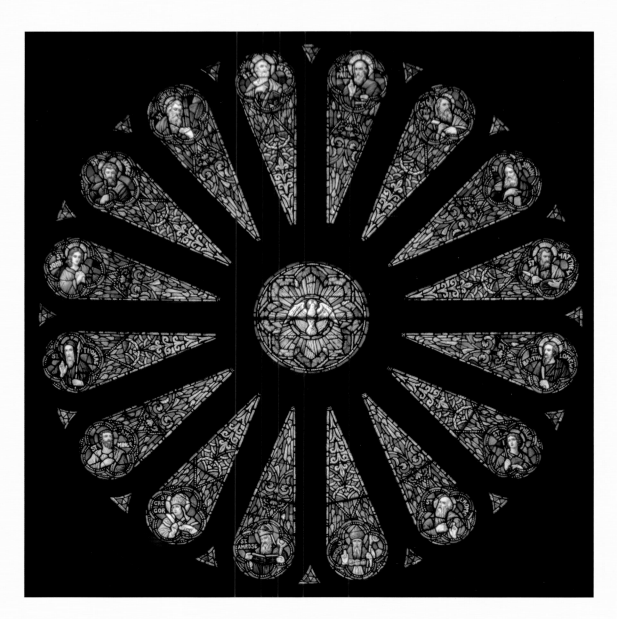

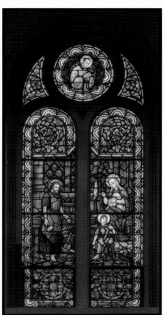 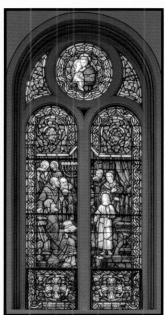

Left: *Stained glass windows of the Holy Family and the Finding of the Child Jesus in the Temple.* Above: *Rose window above the choir loft shows sixteen saints, with the dove of the Holy Spirit in the center.*

EPIPHANY OF OUR LORD

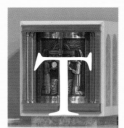

The first church commissioned by Archbishop John J. Glennon was the Epiphany of Our Lord in 1931. The parish covered the entire southwest section of the city. It also was the first church of a multinational congregation: 40 percent of Irish ancestry, 40 percent German, 15 percent Polish, and a scattering of Italian families. St. Joan of Arc, St. Gabriel, and St. Raphael parishes were carved from its original territory. Hof Construction built the church of basilica brick.

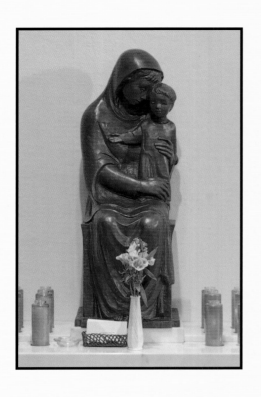

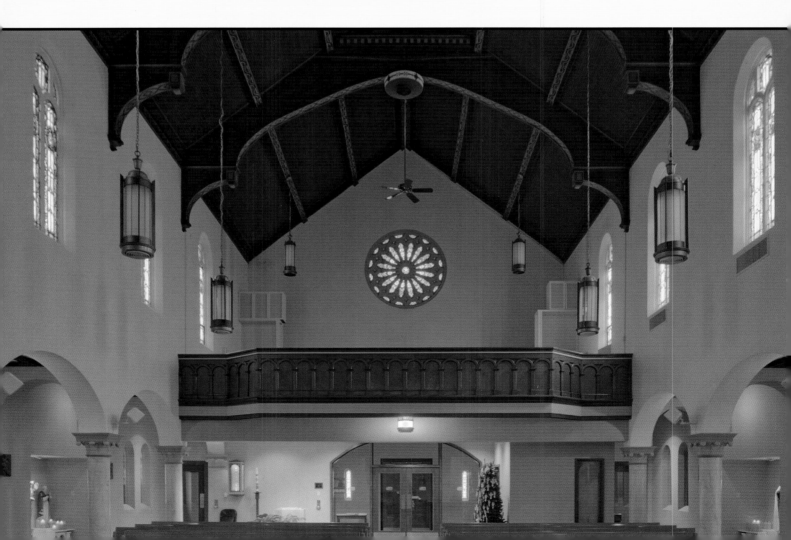

Opposite Top Left: *Madonna and the Infant Jesus.* Opposite Top Right: *14th Station of the Cross—Jesus is placed in the tomb.* Above Left: *St. Joseph.* Above Right: *Crucifix.*

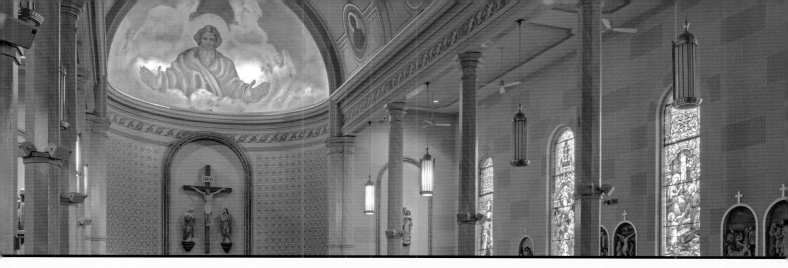

St. Francis Borgia

welve Catholic families from Hanover settled on the south bank of the Missouri River in Franklin County and named their settlement Washington. According to an agreement with Bishop DuBourg in 1818, Jesuits agreed to missionize the area on the lower Missouri. Among the Jesuits, Father Martin Seisl, already an established writer in Germany, was especially remembered. In 1894, St. Francis Borgia and other parishes were transferred to the Franciscans of the Sacred Heart Province.

Lower Right: *Stained glass window. "Praise the Lord, all you people!" in German.*

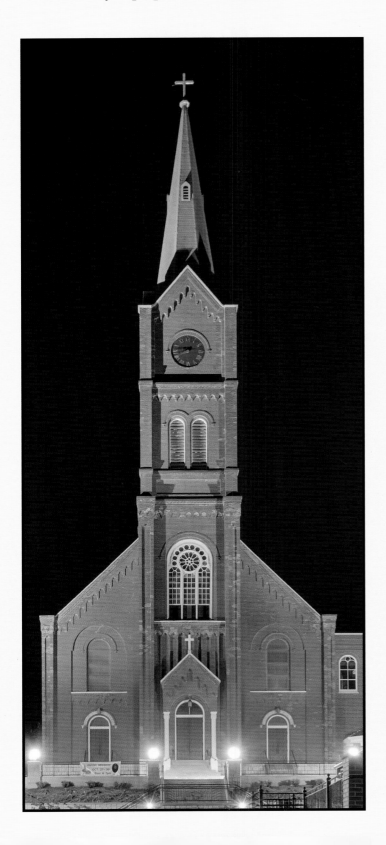

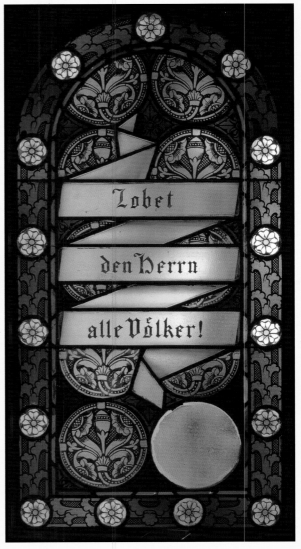

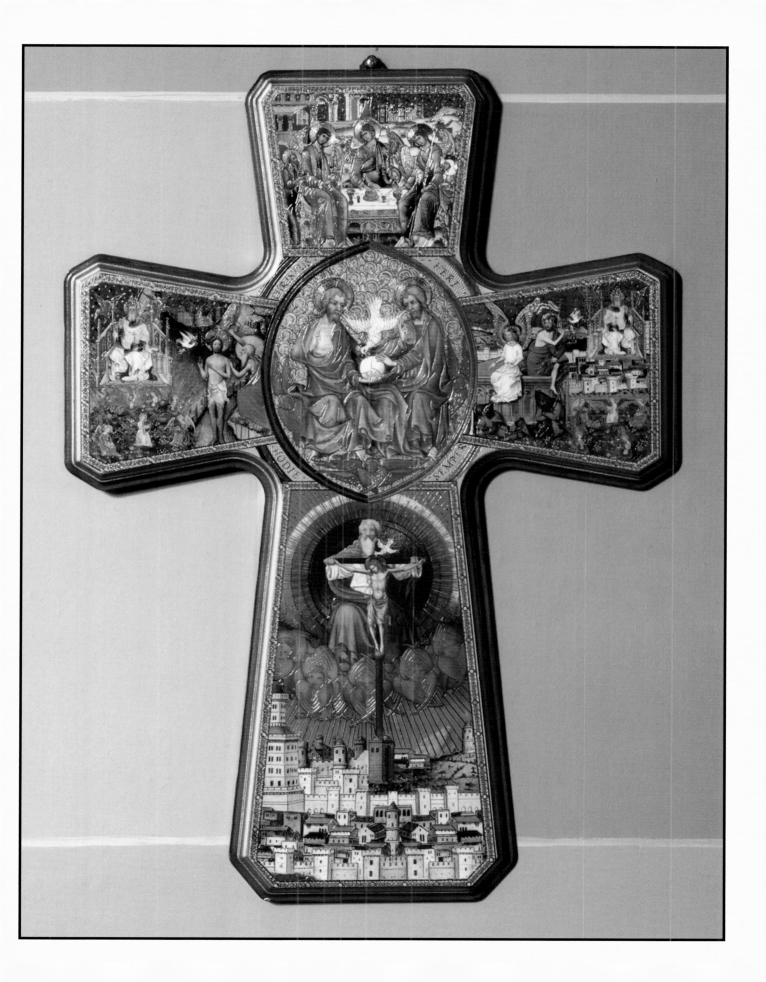

The tornado of 1896 totally destroyed the plain building that was St. Francis de Sales Church, begun in 1867. The present church of German Gothic design, with only a single tower, was designed by Viktor Klutho and dominates a wide area of the South Side. The high altar is awe-inspiring.

Long the leading church among German immigrants on the South Side, it welcomed St. Louis's first bishop of German ancestry in 1934, Most Reverend Christian Winkleman, D.D., later bishop of Wichita, Kansas.

St. Francis de Sales

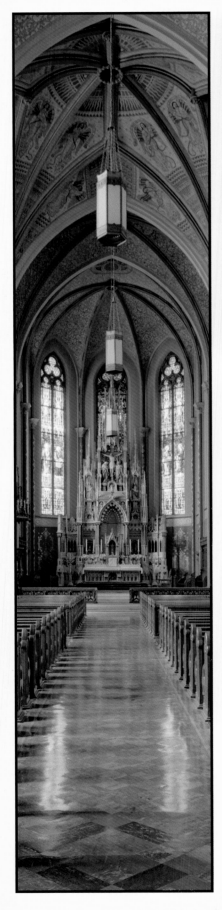

Above: *"Grotesques" in Gothic architecture symbolize sin and folly.* Right: *Baptistery is decorated with mosaics in blue, gold, and brown.*

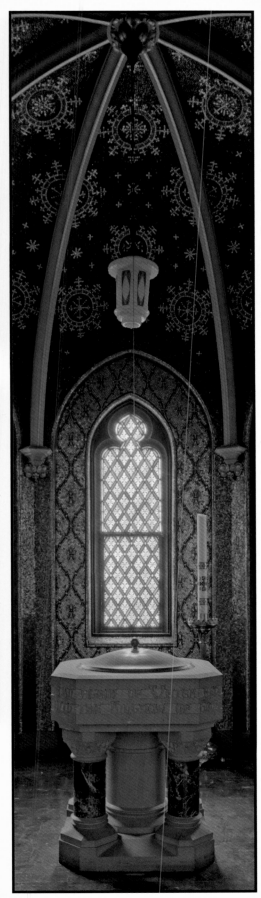

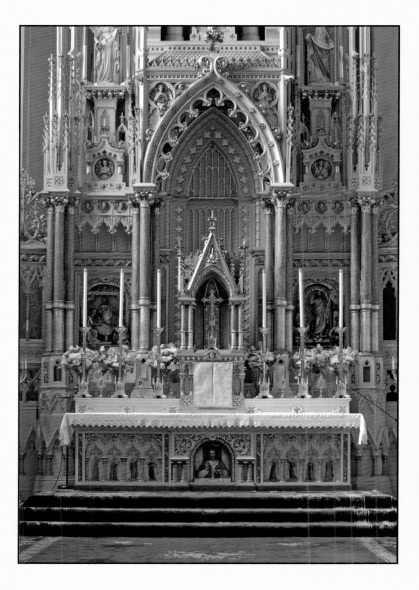

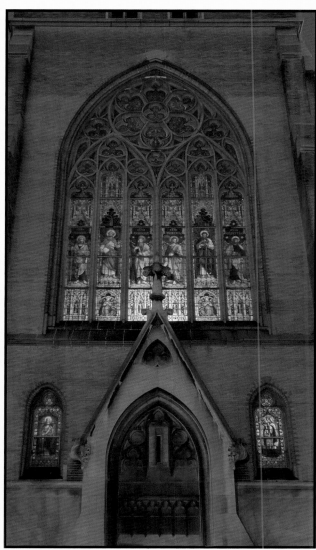

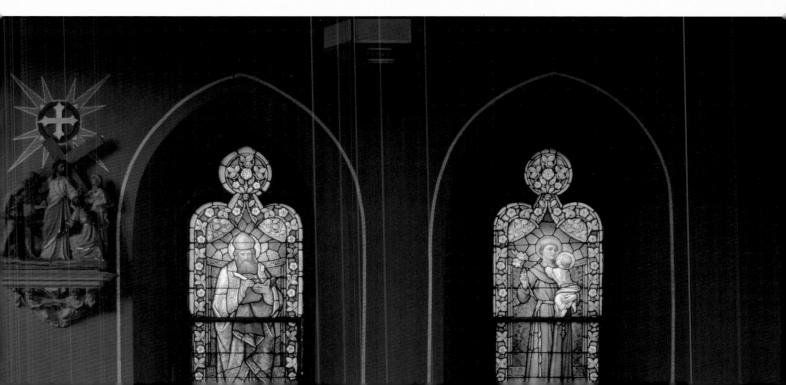

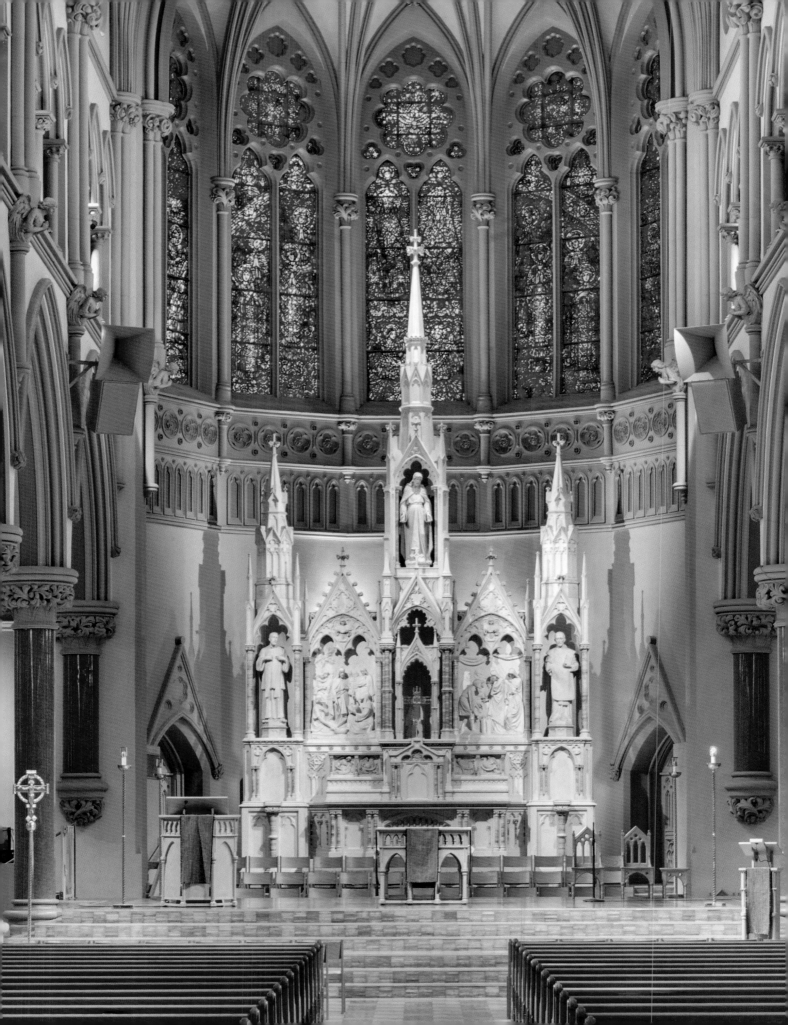

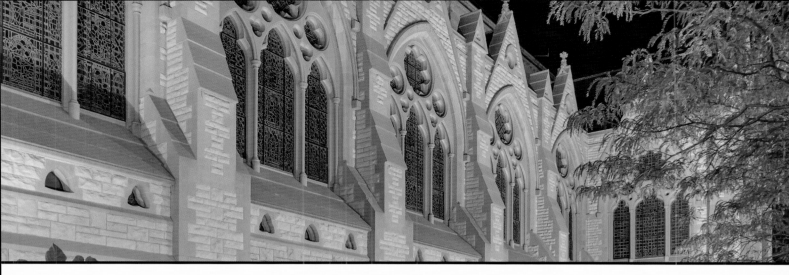

St. Francis Xavier

One of the four original churches in St. Louis, St. Francis Xavier stood at Ninth and Christy. A Jesuit faculty member, Peter Verheyen, designed it. In 1884, as the city moved west, a basement church was opened at Grand and Lindell. A beautiful French Gothic structure designed by William Walsh gradually came to be over the years. The transepts feature the art glass of Emil Frei, Jr., the best of his many works.

Legend has it that the architect modelled St. Francis Xavier after the church at Cobh, the Port of Cork, Ireland. Its elongated steeple detracts from its beauty. The St. Louis church has a more harmonious steeple.

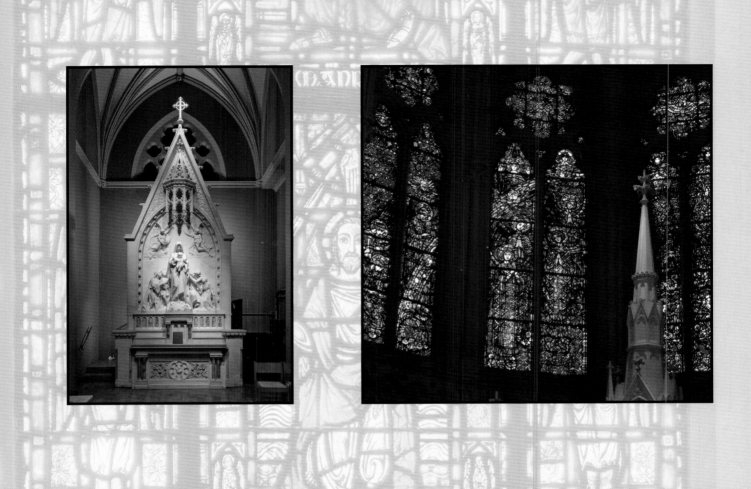
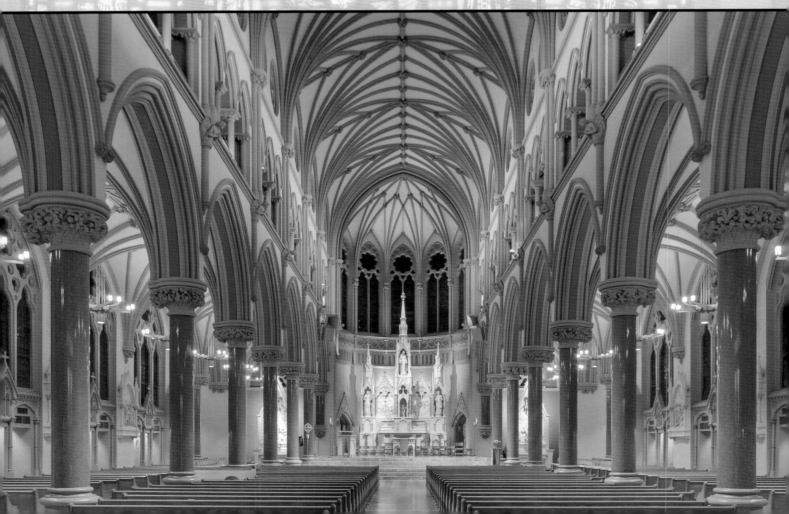

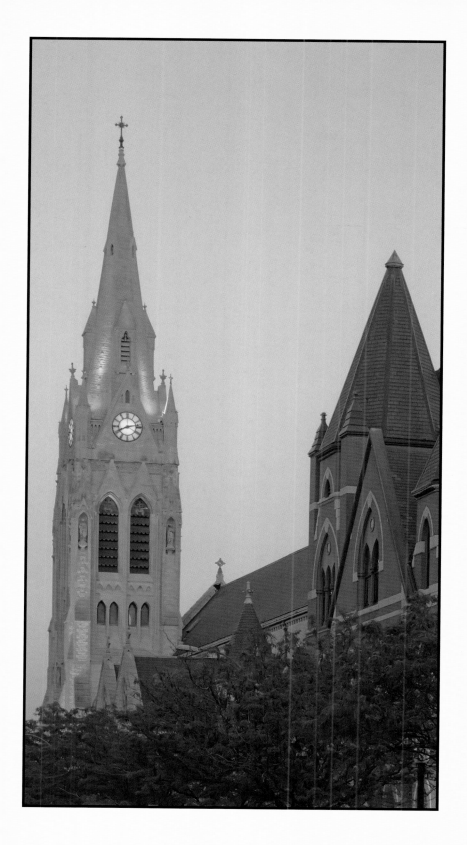

Opposite Left: *Altar of the Blessed Virgin Mary.*
Above Right: *Behind the baptismal font, a fountain outside of the church is seen through open doors.*

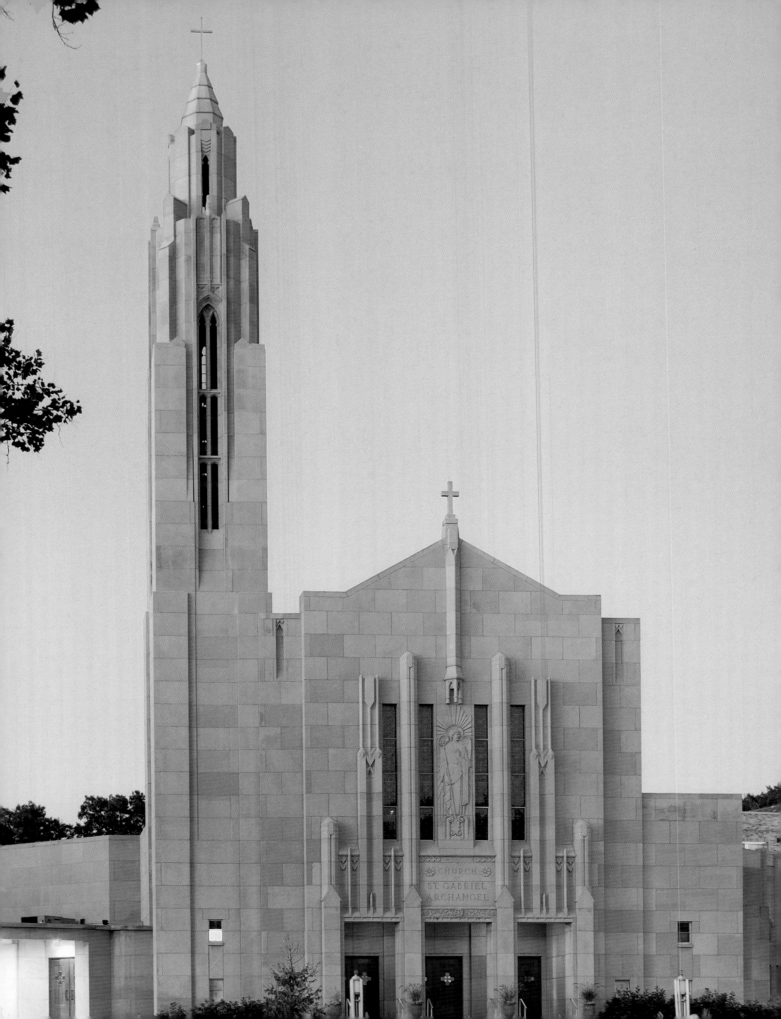

St. Gabriel the Archangel

St. Gabriel the Archangel Church occupies a conspicuous location on Nottingham at Tamm Avenue, directly opposite the northwest corner of Francis Park in Southwest St. Louis.

The church faces that corner, and the pews in each section are perpendicular to the altar so that every worshipper feels close to the celebrant.

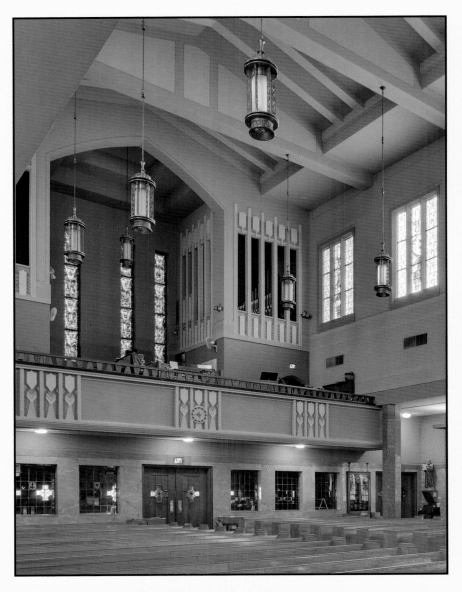

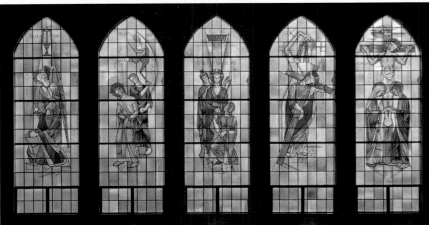

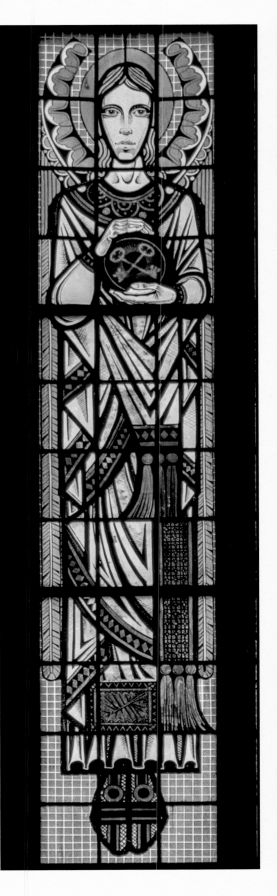

Above: *Stained glass windows represent the Sorrowful Mysteries of the Rosary.* Right: *An angel in the clerestory holds the Keys of St. Peter. Opposite Far Right: Baptismal font before a statue of St. Joseph and the Christ Child; holy oils are reserved under the statue.*

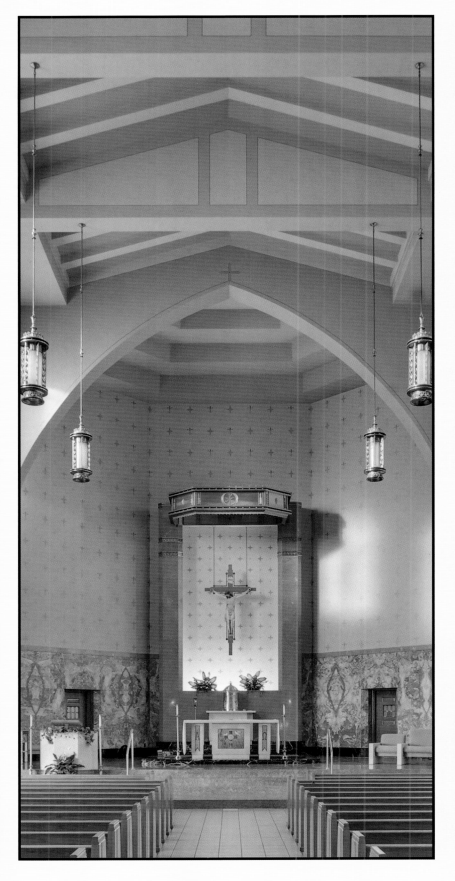

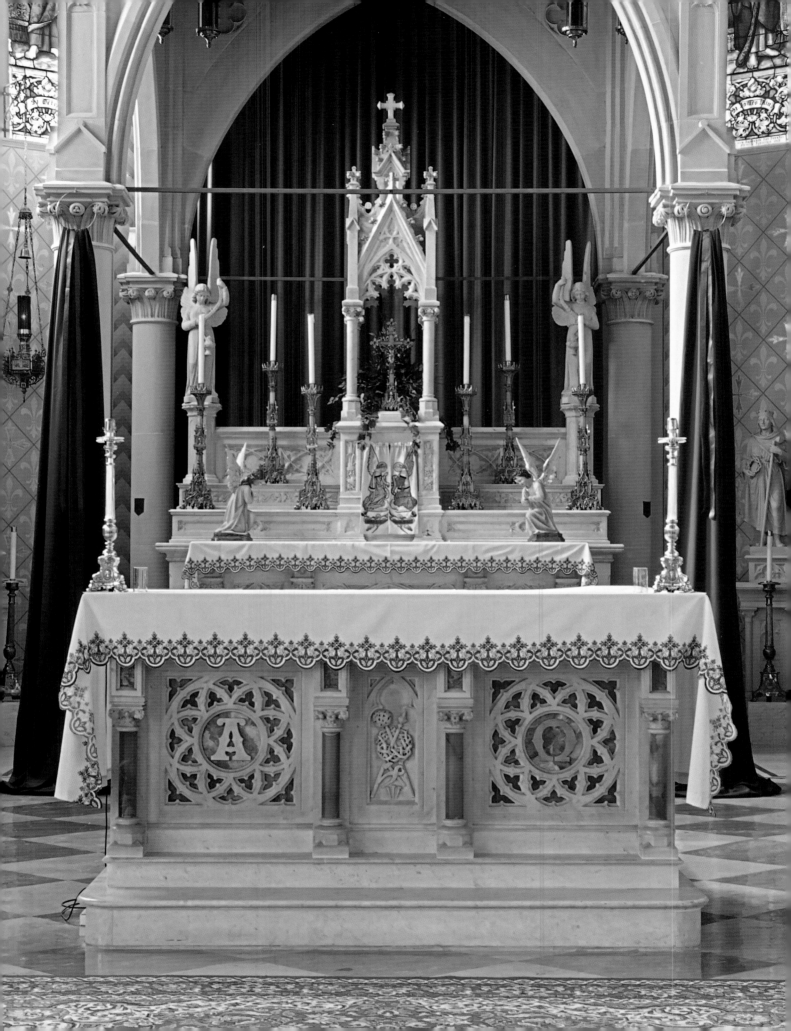

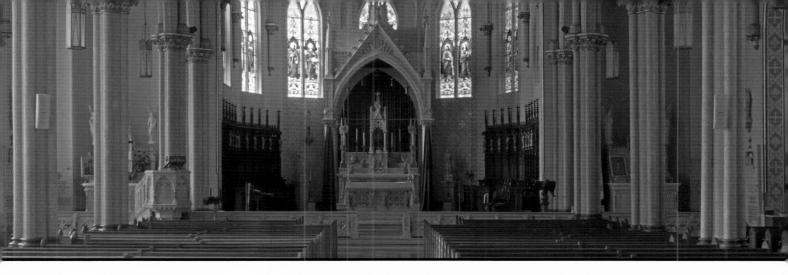

CHURCH OF STE. GENEVIEVE

Father Franz Xavier Dahmen, a Vincentian, shepherded the many German immigrants who joined the original French community. During the years of Archbishop John Glennon, a large church of German Gothic design went up on the presumption that it would be the cathedral of a Southeast Missouri diocese that never came to be, at least not yet. It could fittingly serve in that capacity at some future time.

The oldest settlement in colonial Missouri, Ste. Genevieve seemed more likely to be the choice of Bishop DuBourg on his arrival in 1818. Instead, he chose churchless St. Louis.

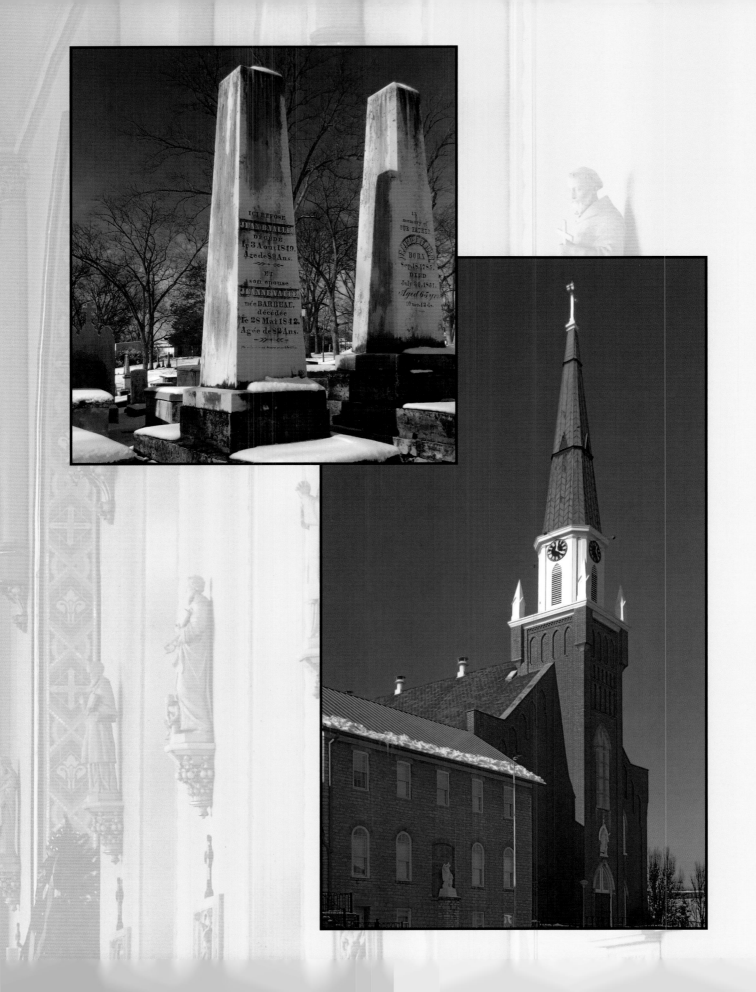

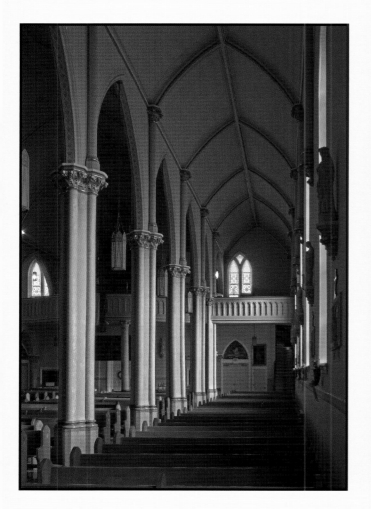

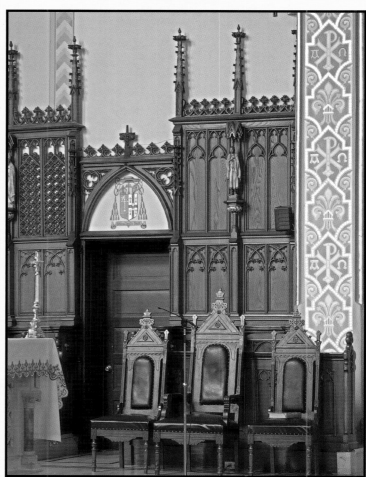

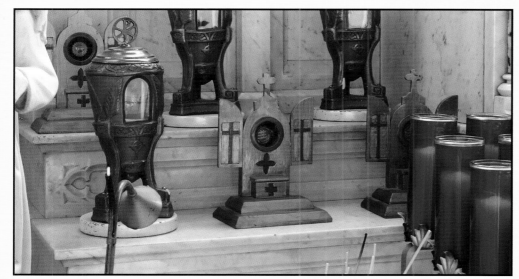

Opposite Left: *The nearby cemetery contains the graves of many French settlers.* Above: *Some of the church's many relics displayed for veneration.*

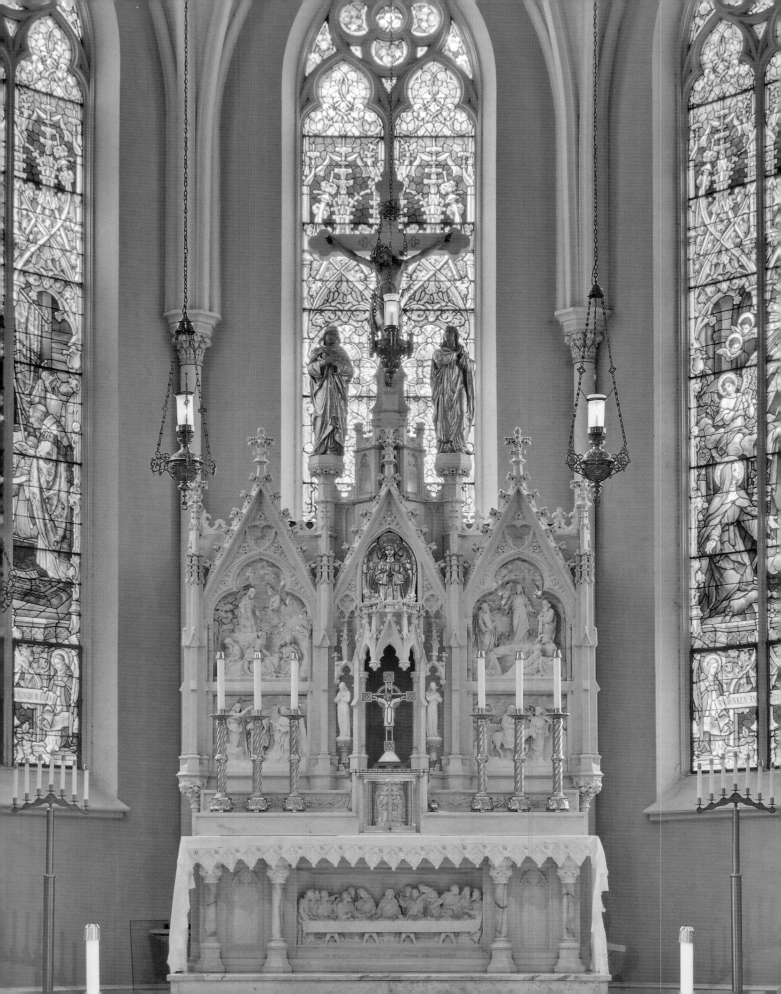

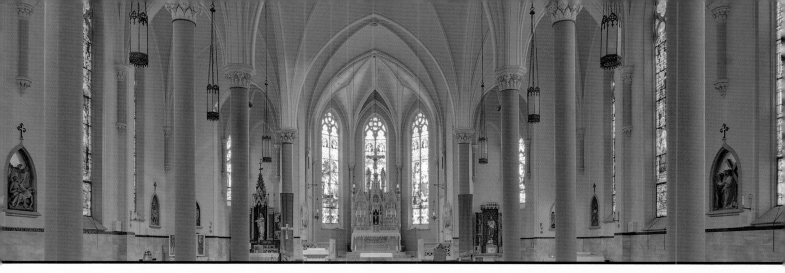

HOLY CROSS

Father Casper Doebbner, pastor of Holy Trinity Church, founded Holy Cross in Baden in 1863. The present church was built in 1909. During the pastorate of Monsignor Martin Hellriegel, this parish became a model of liturgical reform. Priests and lay people came from many places to learn the latest in liturgical practice.

The original worshippers were German and Irish, but in 1870 the Irish left to form Mt. Carmel Parish. Holy Cross is an imposing edifice when viewed from the southwest vantage.

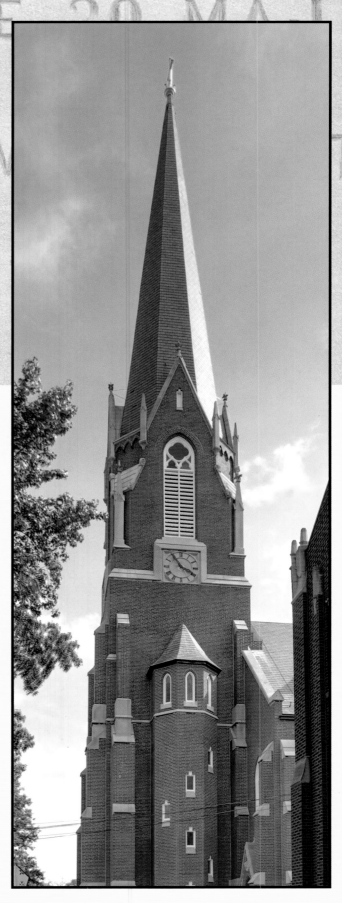

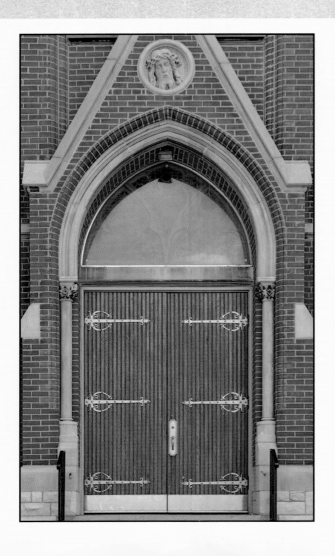

Below: *Tryptich of the Eucharistic Miracle of Walldürn-Baden; tryptich and relics of Sts. Maria Goretti, Pope Pius X, and Rose Philippine Duchesne.* Right: *Patron saints are painted on movable panels on Mary's altar.*

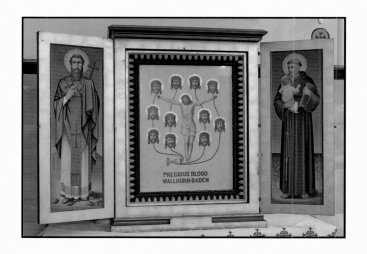

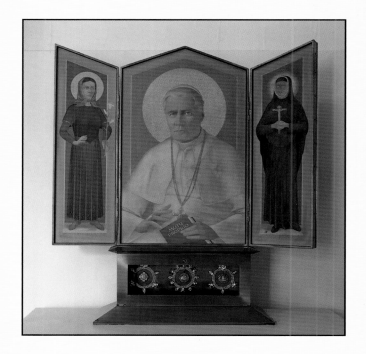

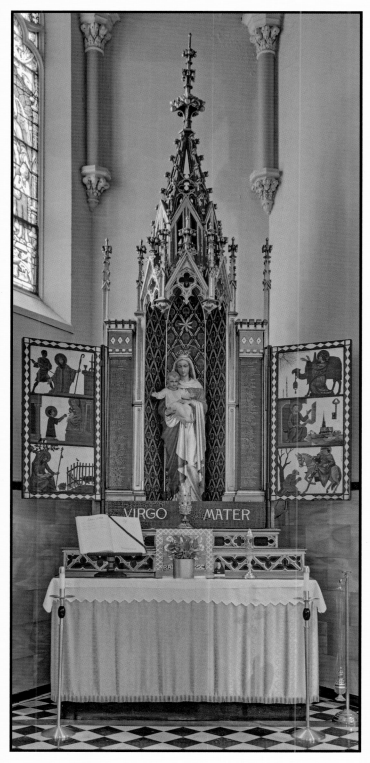

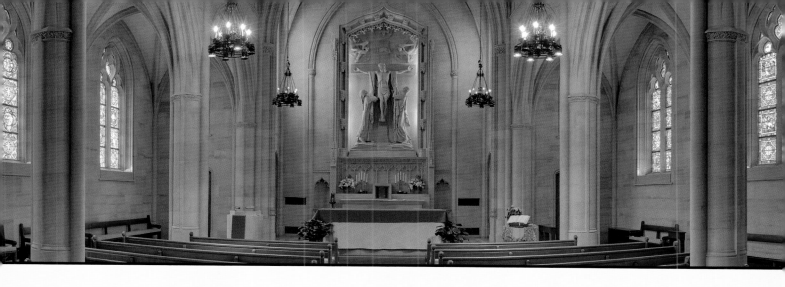

The chapel of the University Medical Center, originally the Desloge Hospital, was the work of the outstanding contemporary architect Ralph Adams Cram in the early 1930s.

Unfortunately, the beauty of the building never caught the spiritual needs of the sick and those who visited them. Sheer beauty is not always enough. A warmth of environment attracts worshippers.

SAINT LOUIS UNIVERSITY HOSPITAL CHAPEL

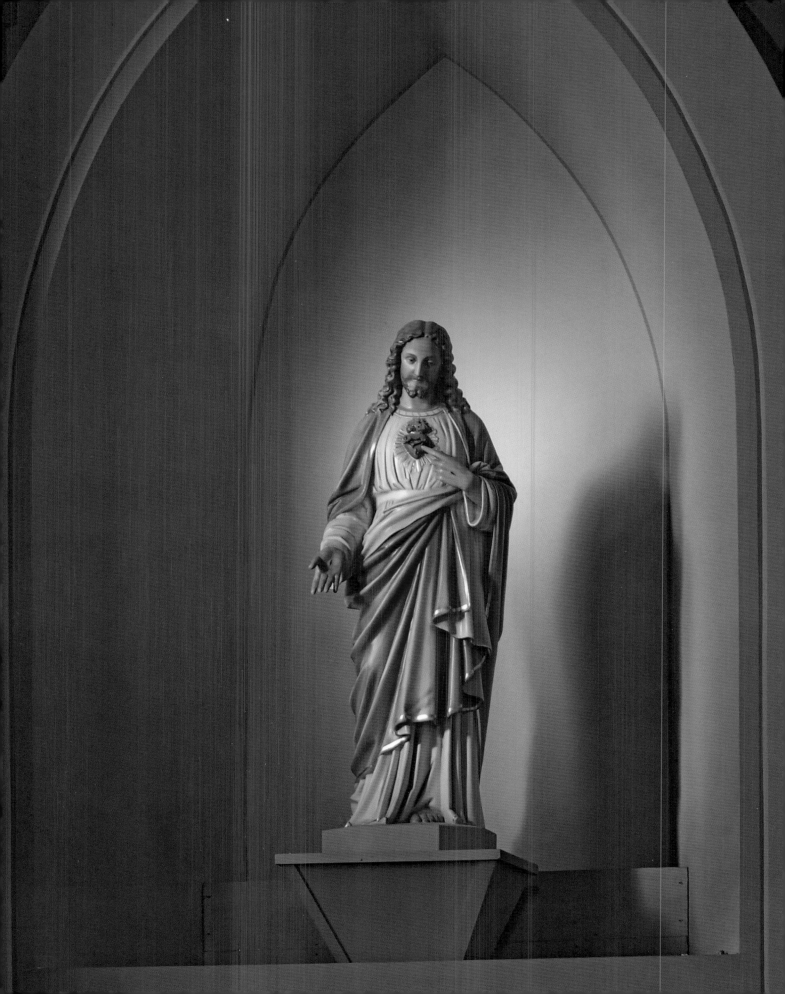

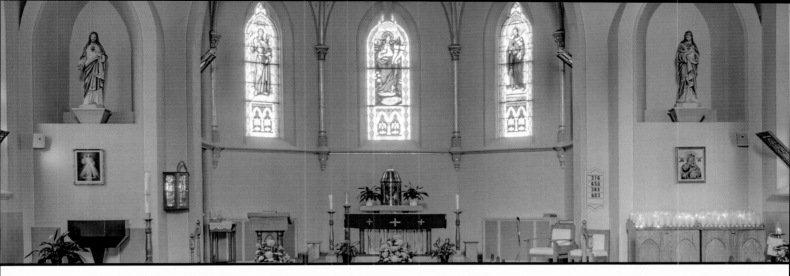

The people of Arnold were served for many years by the pastors of Assumption in Mattese in South County. Eventually, a Gothic church, the Immaculate Conception, dominated the lower Meramec Valley. It is extremely immpressive to motorists traveling south on Interstate 55.

IMMACULATE CONCEPTION IN ARNOLD

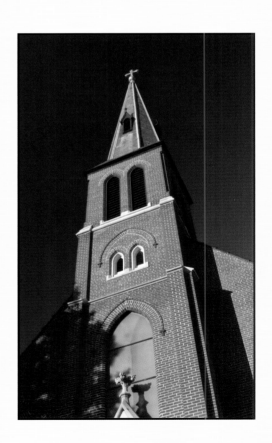

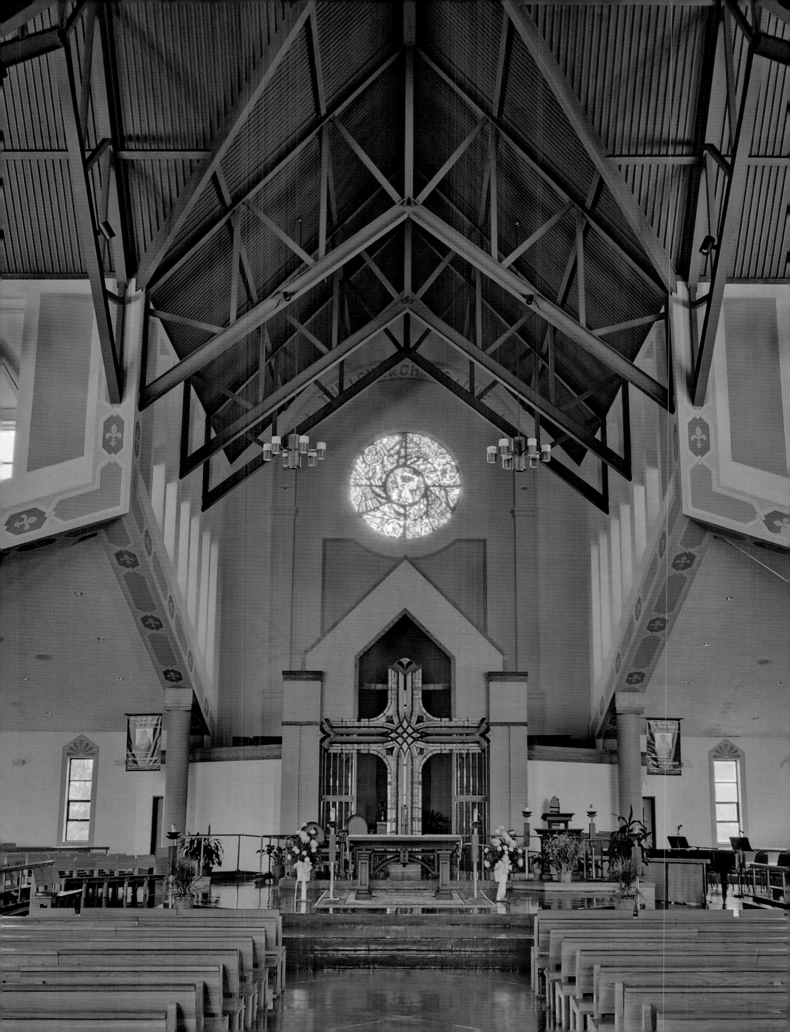

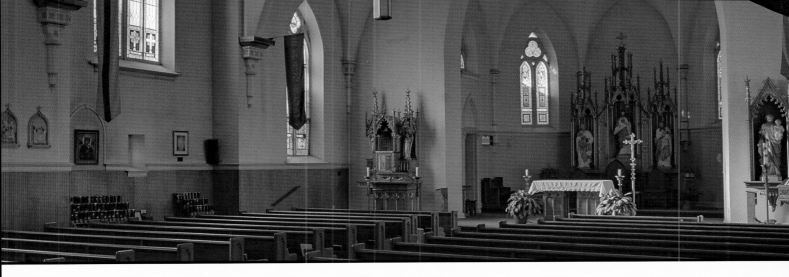

IMMACULATE
CONCEPTION
IN DARDENNE

Jesuit missionaries from St. Charles visited this settlement of French traders in St. Charles County. Gradually, German farmers found the area fertile for agriculture. Eventually, a fine church of German Gothic design graced the community.

The Church of the Immaculate Conception in the fertile fields along the Missouri River reflects the stability and solidity of its parishioners.

Recent growth of the parish led to the construction of a new church, built alongside the old.

Opposite: *Interiors of the new church.*
Above: *The old church.*

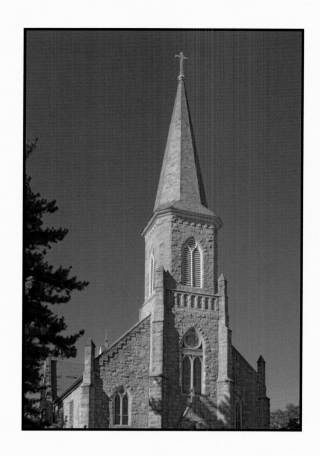

Opposite and Top Left: *Old church*. Bottom and Top Right: *New church*.

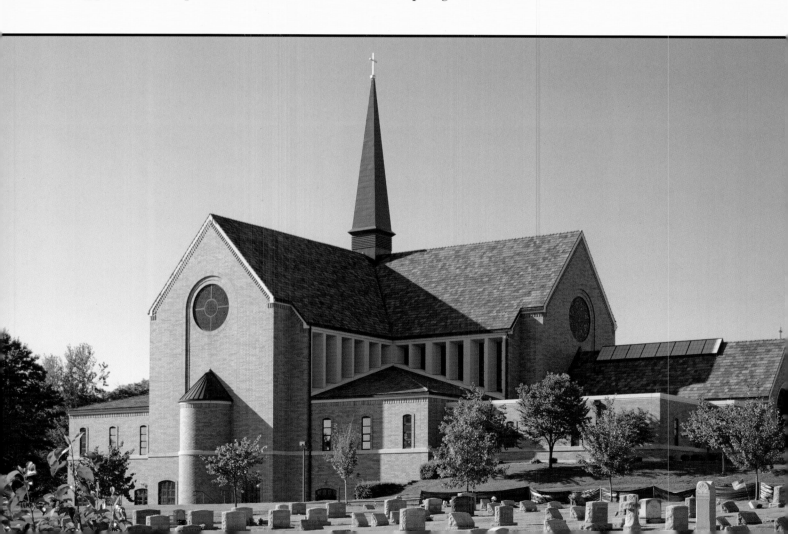

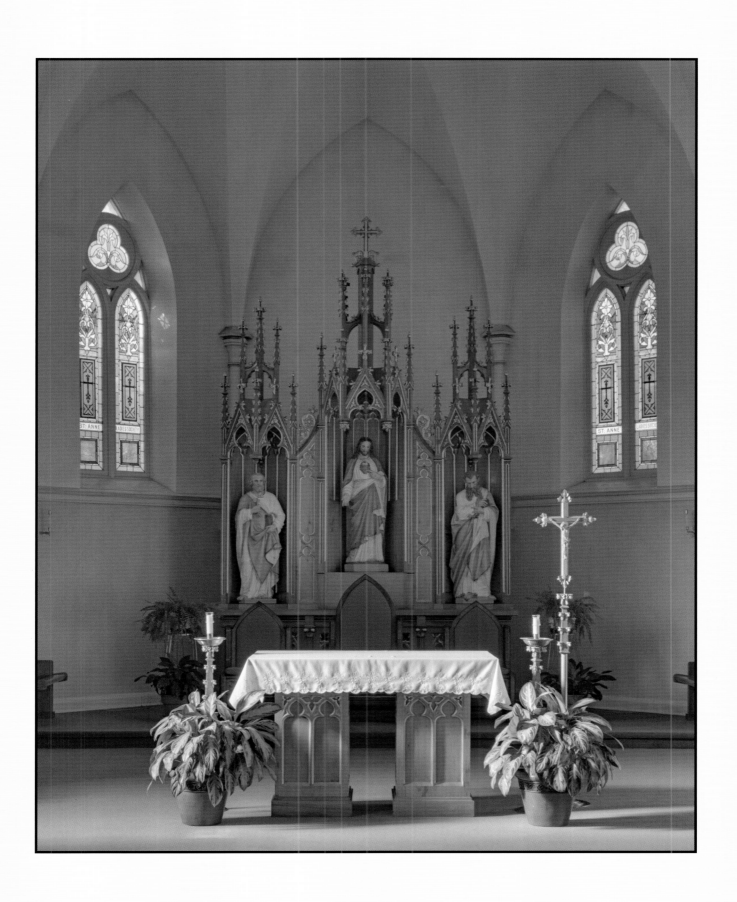

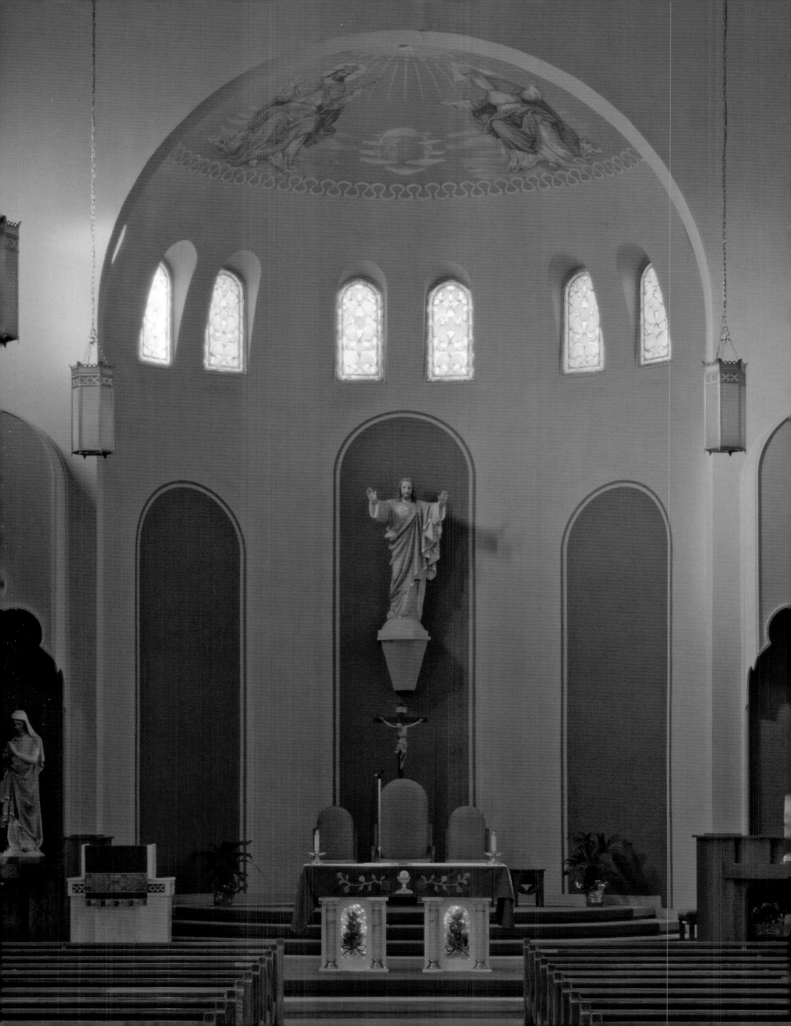

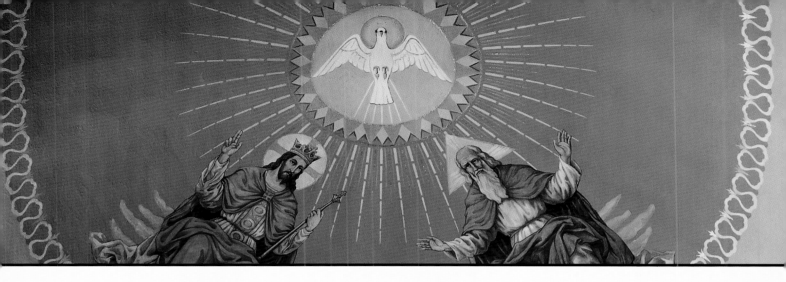

SACRED HEART
IN CRYSTAL CITY

Sacred Heart in Crystal City began in 1881 during the pastorate of Father John May. Several short-term pastors followed, until Father Adolph Holtschneider came in 1904 and gave it stability. It is of Romanesque style, with a tall, square steeple. Paintings of Christ the King and of God the Father adorn the inside of the dome.

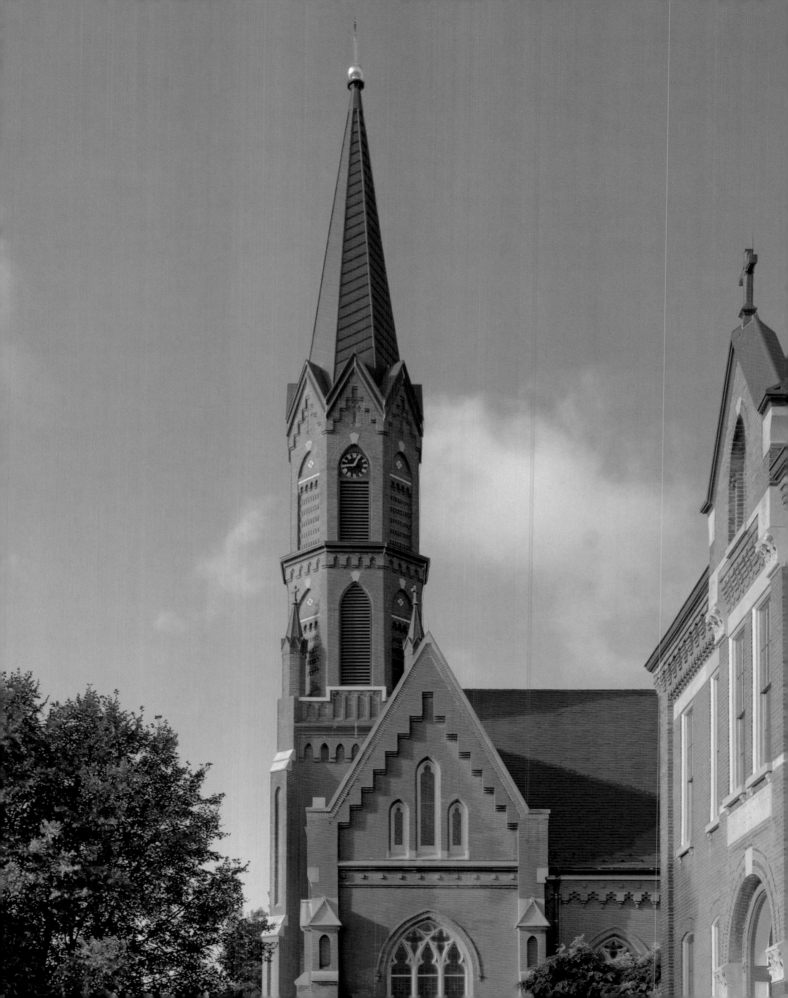

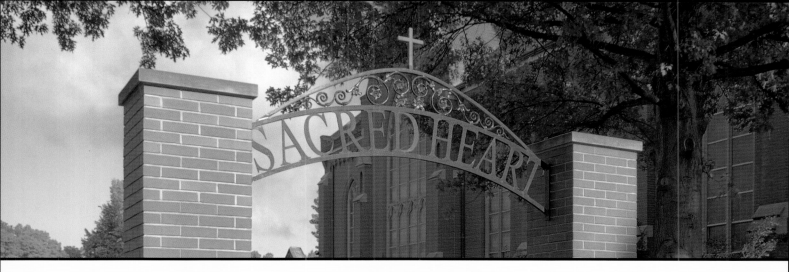

SACRED HEART
IN FLORISSANT

Thirty-five German
families in the Florissant
Valley gathered in 1866 to look over
the possibilities of a church and
school. Supported by Archbishop
Peter Kenrick and the Jesuit Provincial
Father Ferdinand Cossemans,
they laid the cornerstone the
same year for a German Gothic
structure. Father Peter DeSmet
blessed the church on October
5, 1861. The parish flourished
and today anchors "Old Town
Florissant." The homes of
parishioners cluster around the
church on the hilltop.

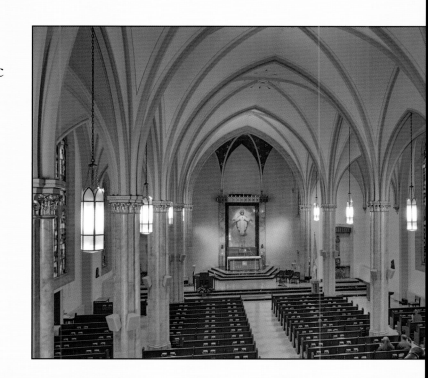

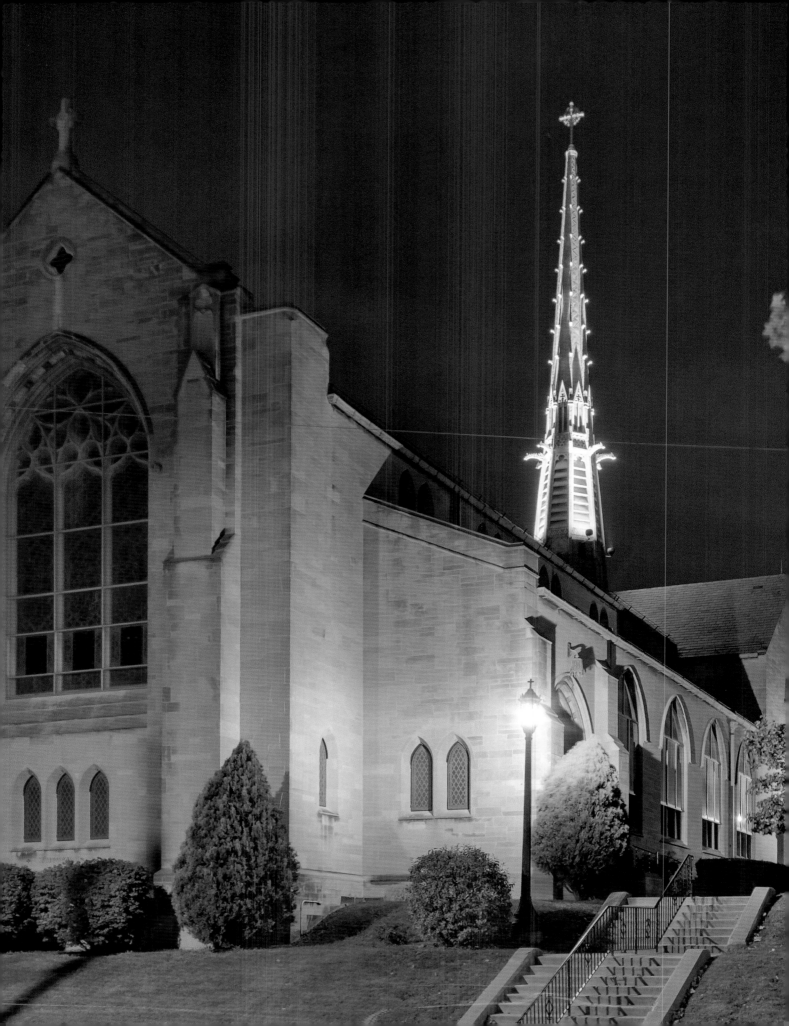

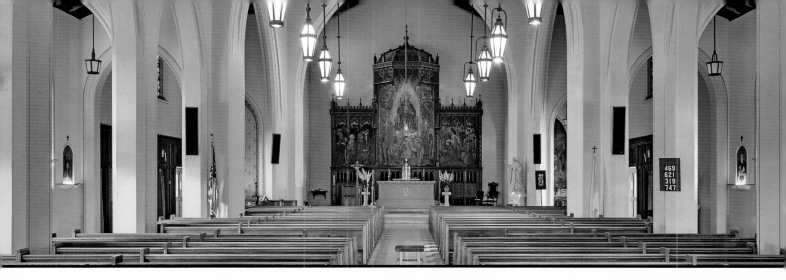

St. James the Greater

embers of St. Cronan and St. Malachy parishes moved to the area south of what became Forest Park in the years just before the Civil War. At that time called Cheltenham, it later became unofficially known as "Dogtown." The first church was erected in 1861. The present church, built in 1928, was designed by O'Meara and Hills in the English Gothic style and completed in spite of the Great Depression that struck that year. In recent years, the parish began hosting the People's Parade on St. Patrick's Day.

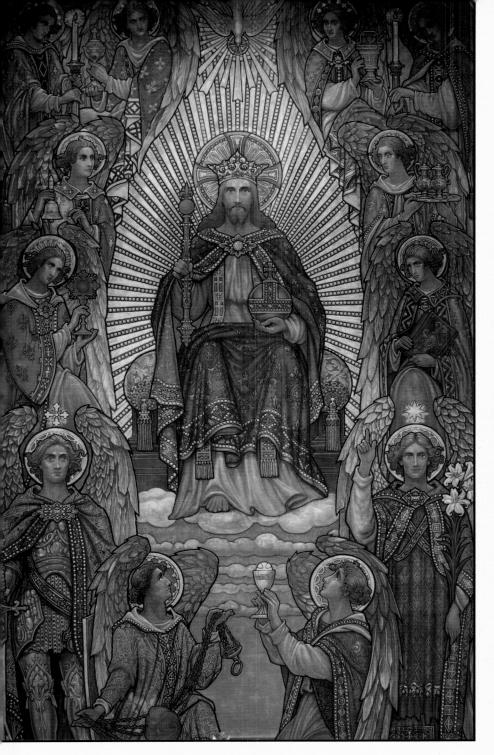

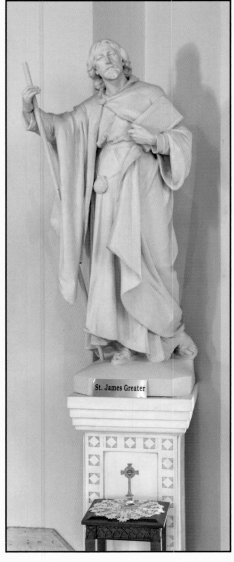

Above: *Tapestry of Christ the King, behind
the high altar.* Right: *Statue and relic of St.
James the Greater, Apostle.*

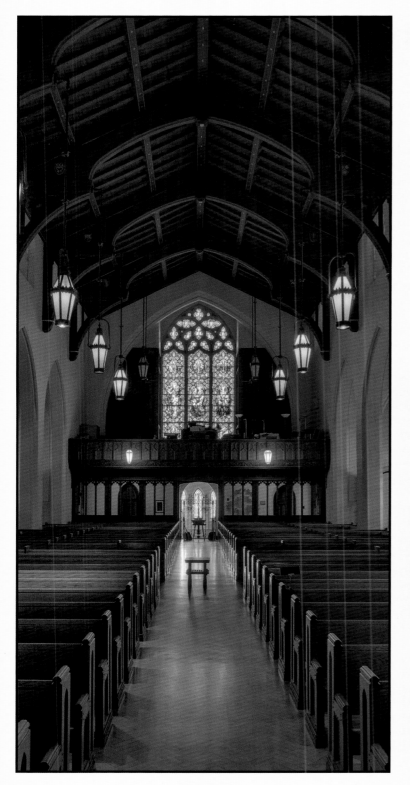
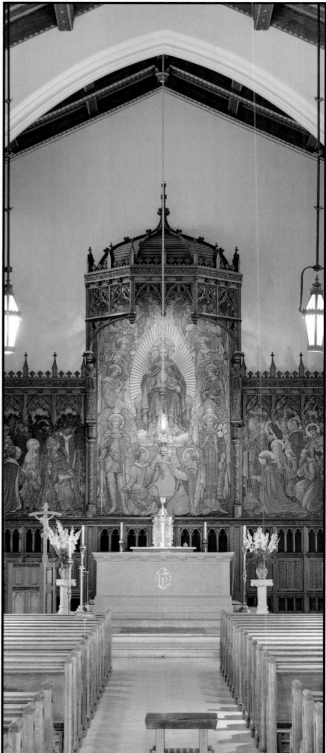

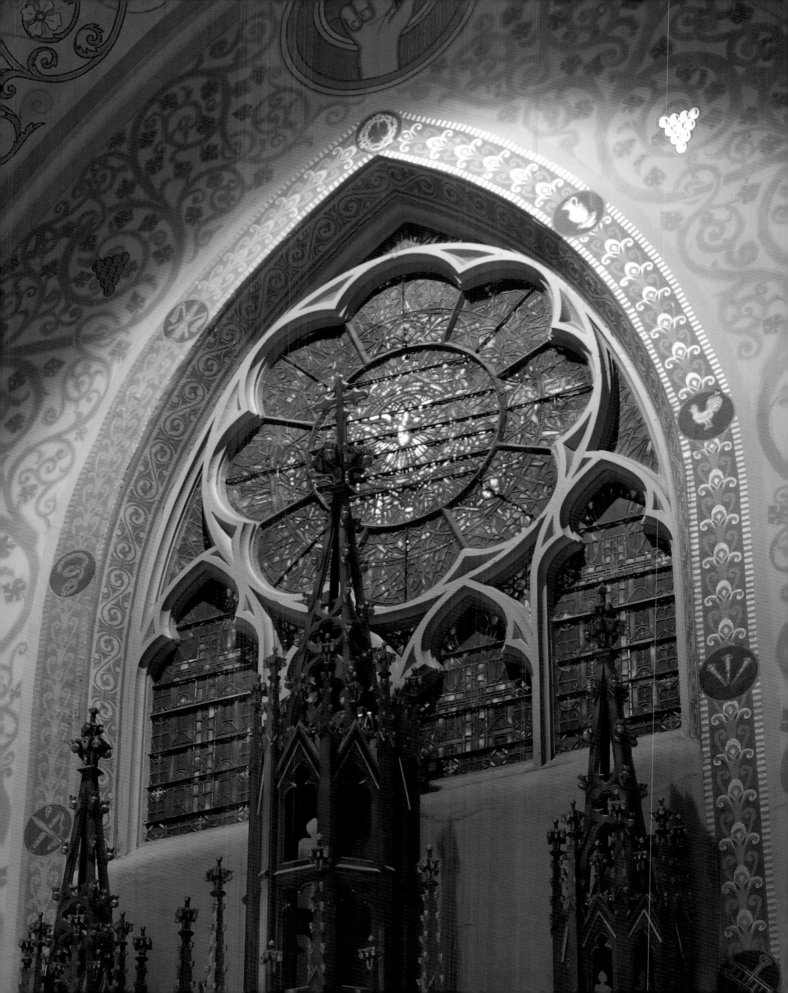

ST. JOHN NEPOMUK

S t. John Nepomuk at Twelfth and Lafayette, the first Bohemian church in America, was designed by Adolphus Druding. It had to be rebuilt after the tornado of 1896 that left only the façade standing. Shortly after, Monsignor Joseph Hessoun and editor Hynek Dostal made it the leading Bohemian parish in America. This was true even though the Lake Cities, rural areas of Nebraska, and south Texas had larger numbers of Bohemian residents. St. John Nepomuk will continue as a shrine.

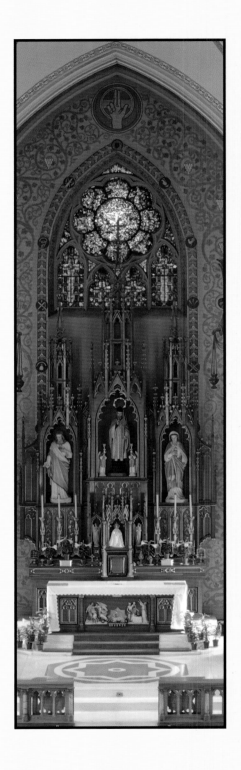

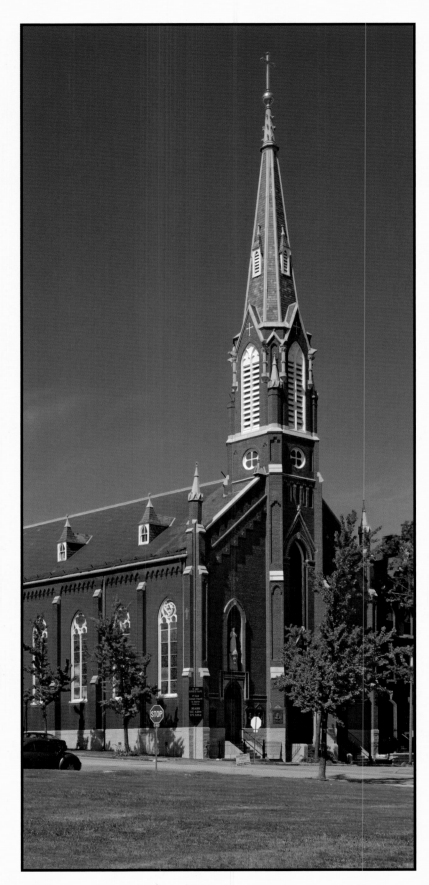

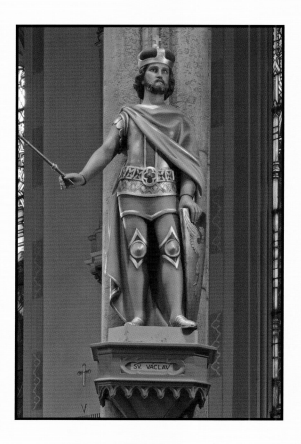

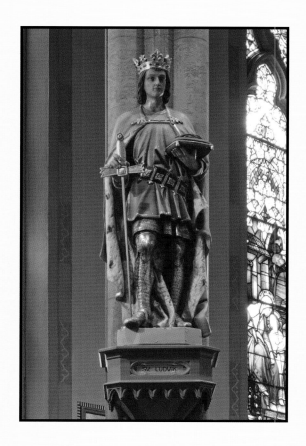

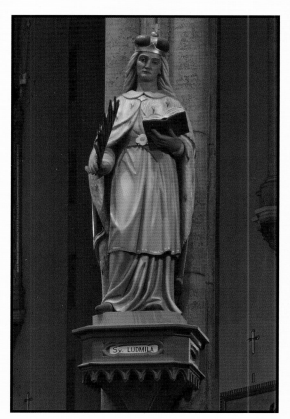

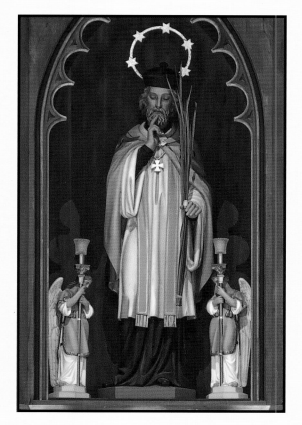

Clockwise from Upper Left: *Statue of St. Wenceslaus; St. Louis IX, King of France; St. John Nepomuk; and St. Ludmila.*

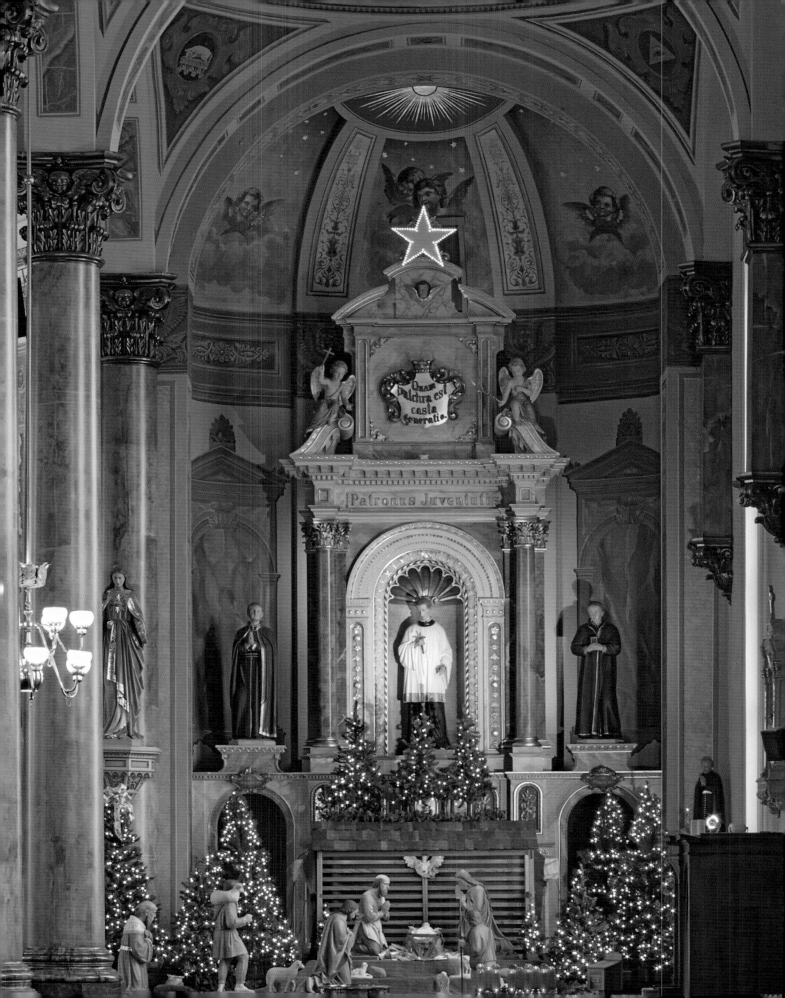

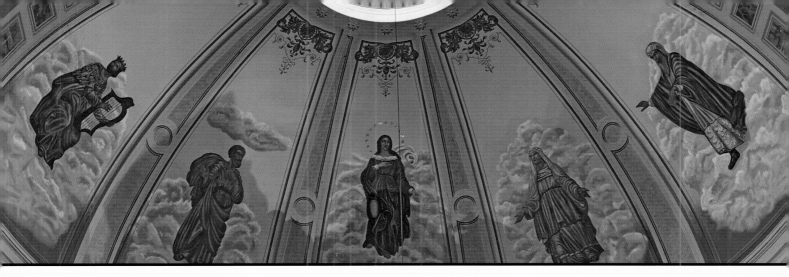

St. Joseph

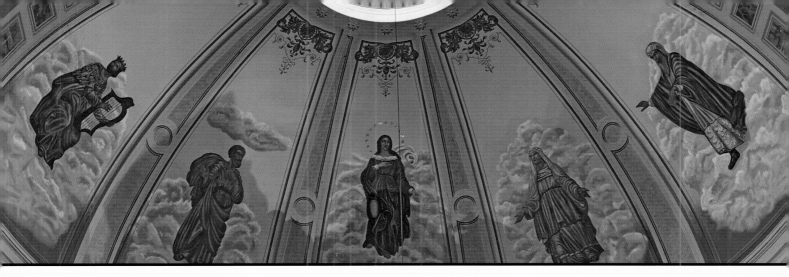 n land donated by Ann Biddle, the diocese opened a church at Eleventh and Biddle in the early 1840s for Germans living on the Near North Side. St. Joseph, a large church of Baroque style, was built during the Civil War facing Biddle Street. A Swiss, Father Joseph Weber, served most of his life at St. Joseph.

Apparently designated for the headache ball in the days of Cardinal John J. Carberry, St. Joseph was saved by a joint effort of many individuals. It is now a vibrant shrine.

Clockwise from Upper Left: *Statue of the Blessed Virgin Mary with the Infant Jesus; Holy Death of St. Joseph; St. Joseph with the Child Jesus; St. Ignatius of Loyola; St. Pio of Pietrelcina (Padre Pio); and St. Peter Claver.* Opposite Right: *The hand-carved pulpit is from an old Jesuit seminary.*

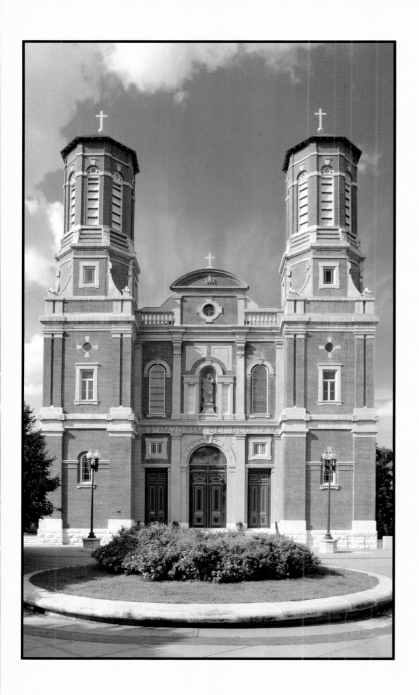

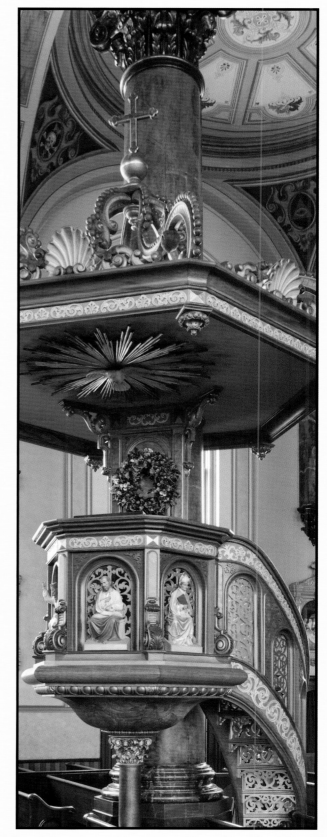

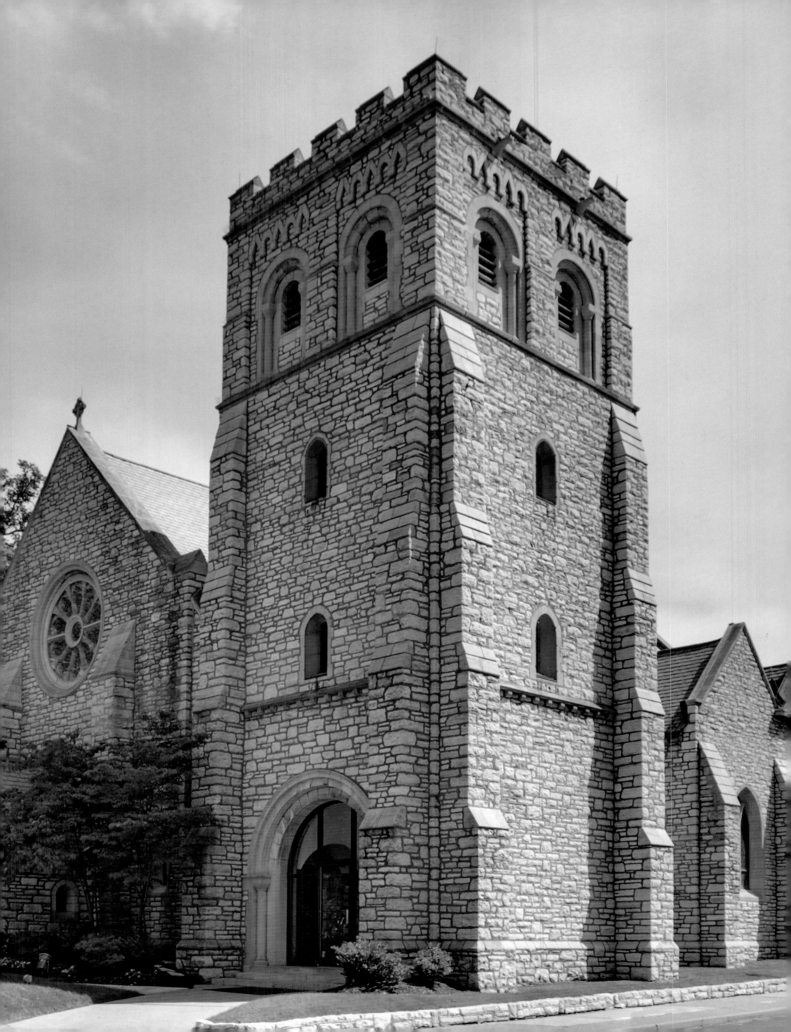

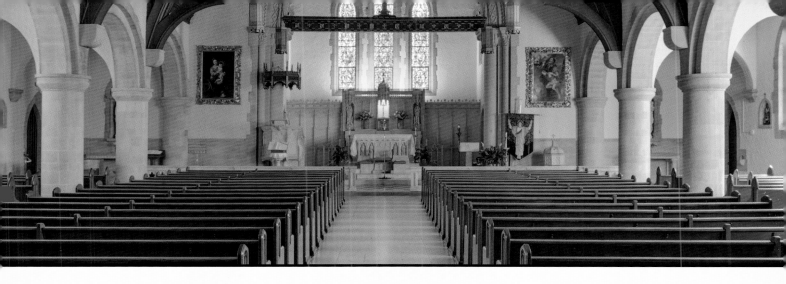

Father Francis O'Conner organized a parish in University City in 1916 by gathering the people in a stucco chapel he financed himself. A stone church of Norman Gothic architecture was built in 1918, and the parish still flourishes.

The square Norman Tower seems to reflect the stability of its people. The church blends well with the neighborhood.

Our Lady of Lourdes

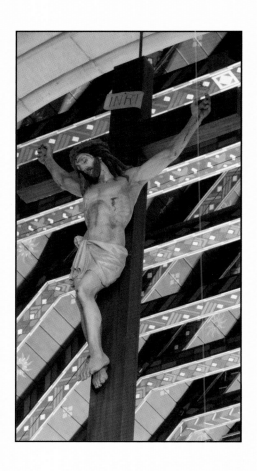

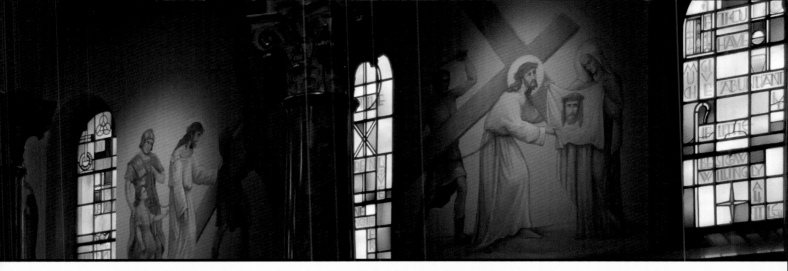

Our Lady
of Sorrows

O ur Lady of Sorrows, of
Lombardy Romanesque
architecture, on Kingshighway at Rhodes,
was one of the last predominantly German
parishes in the city. It began in 1911 and
covered a wide territory that later became
three parishes: St. George, St. John the
Baptist, and St. Mary Magdalen.

Even though the parish boasted a Germanic
background, its two correspondents in the
Review, Father Francis Cleary on Scripture and
a layman, Tom Kavanaugh, in movie appraisal,
were of Irish ancestry.

Above: *Large paintings make up the Stations of the Cross.*
Opposite: *The church's tower at sunrise.*

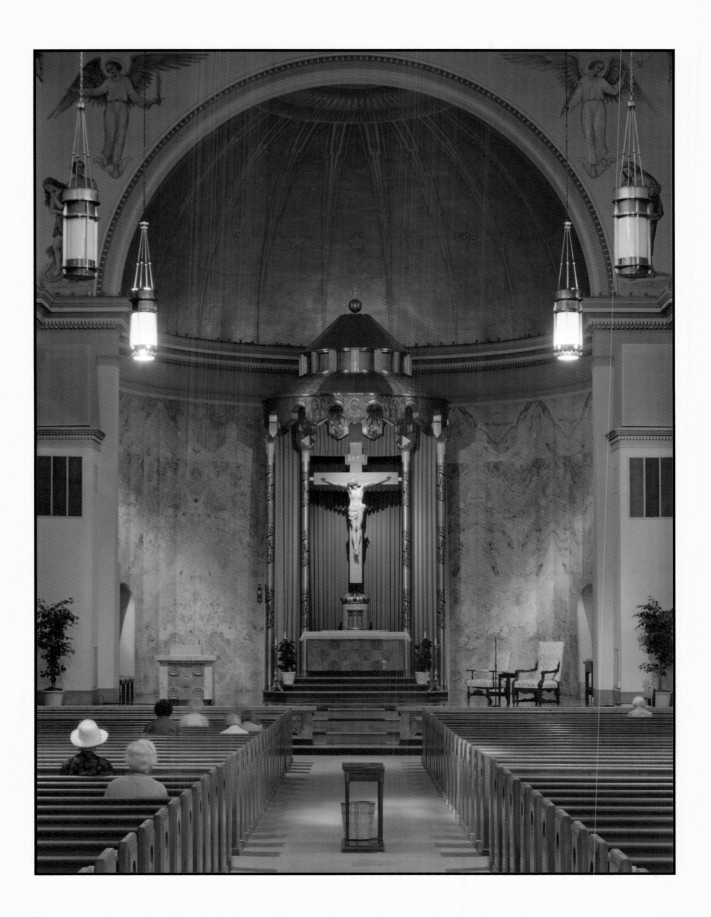

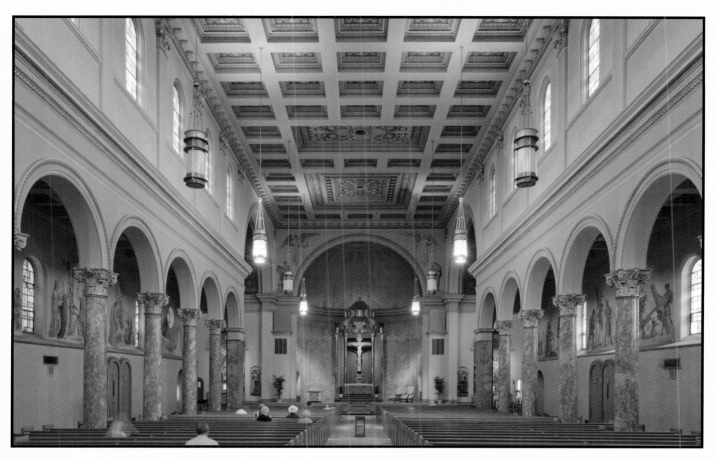

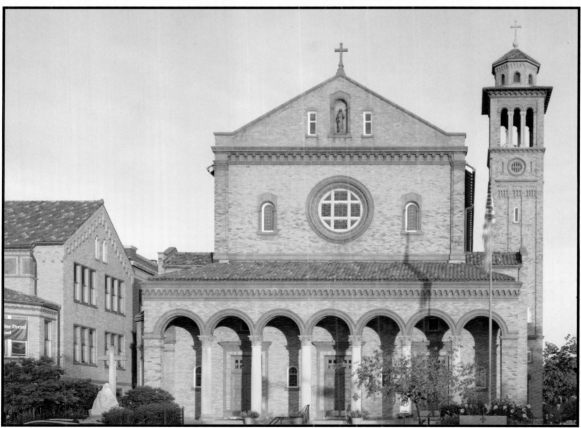

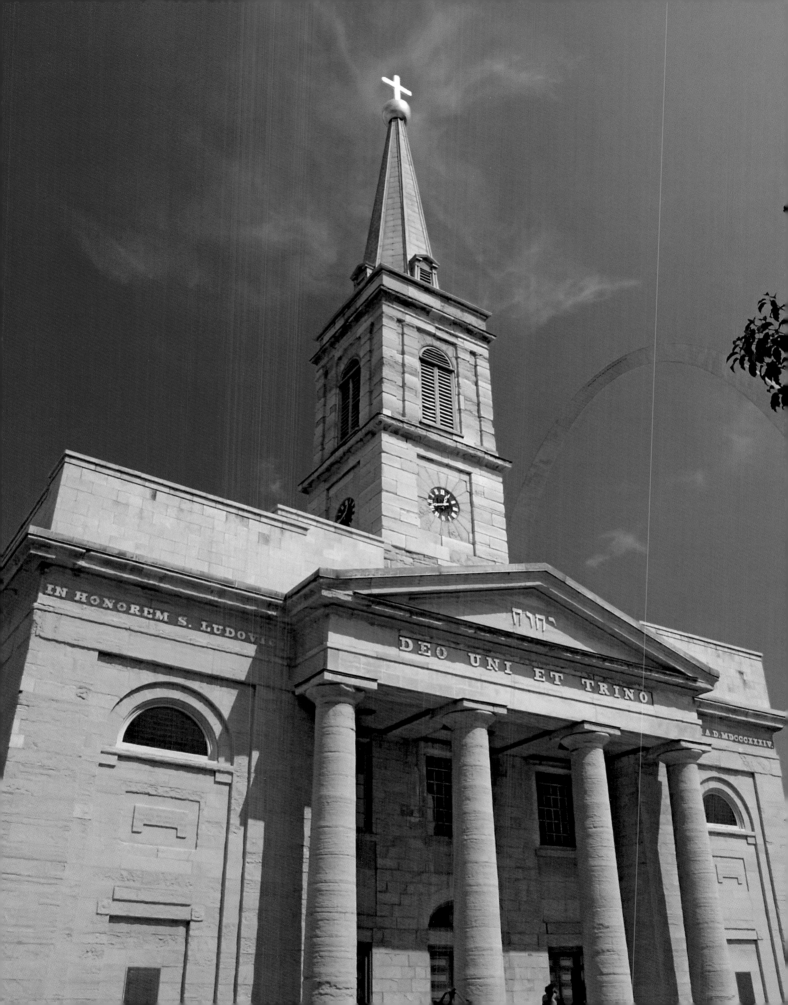

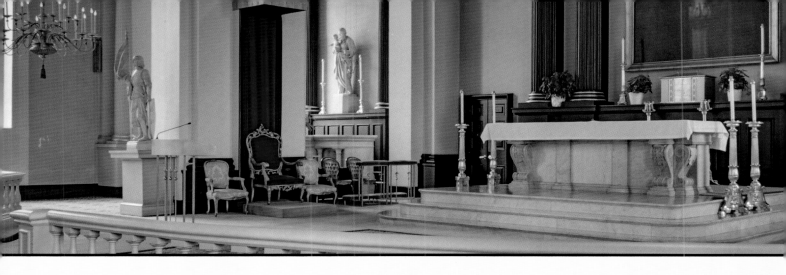

THE OLD CATHEDRAL

he Old Cathedral was a stone building of the Federal style, facing south on Spruce Street three blocks from the river. Construction began in 1832 and was finished in 1834. A civic parade marked the occasion of the dedication, with Bishop John Baptist Purcell of Cincinnati and Bishop Joseph Benedict Flaget of Bardstown assisting Bishop Joseph Rosati. A long-term lease on the remainder of the church property paid the heavy cost of the building.

Only when one pictures the days on the frontier can he appreciate the impact this building had on western travellers.

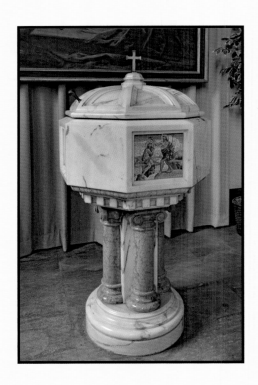

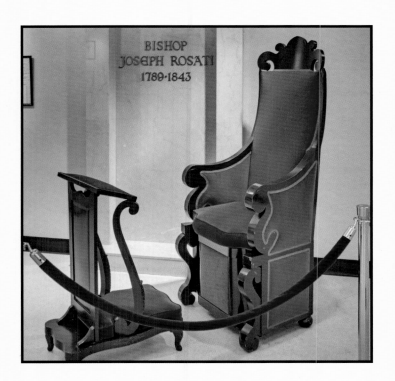

Above Right: *The tomb of Bishop Rosati is beneath the church.* Opposite Left: *Crucifixion painting is copied from an original by Diego Velázquez.* Opposite Right: *Altar of the Blessed Virgin Mary.*

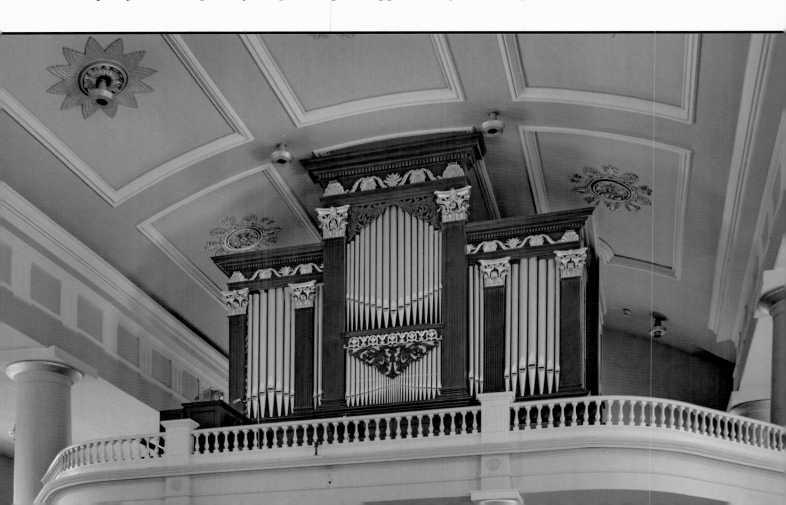

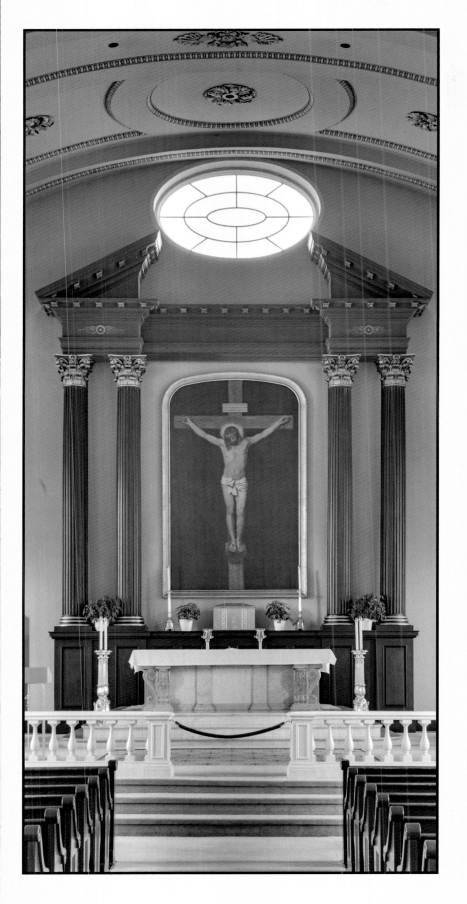

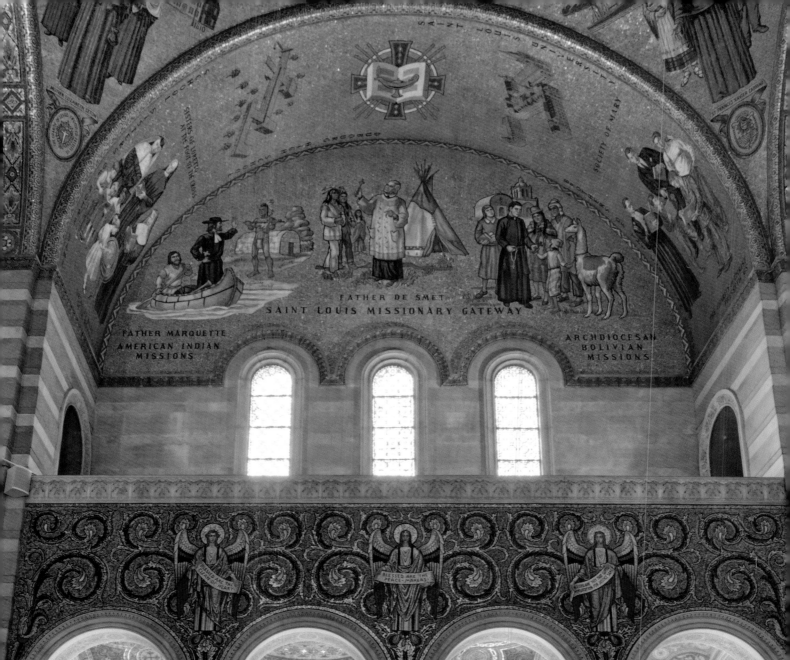

FATHER DE SMET

SAINT LOUIS MISSIONARY GATEWAY

FATHER MARQUETTE
AMERICAN INDIAN
MISSIONS

ARCHDIOCESAN
BOLIVIAN
MISSIONS

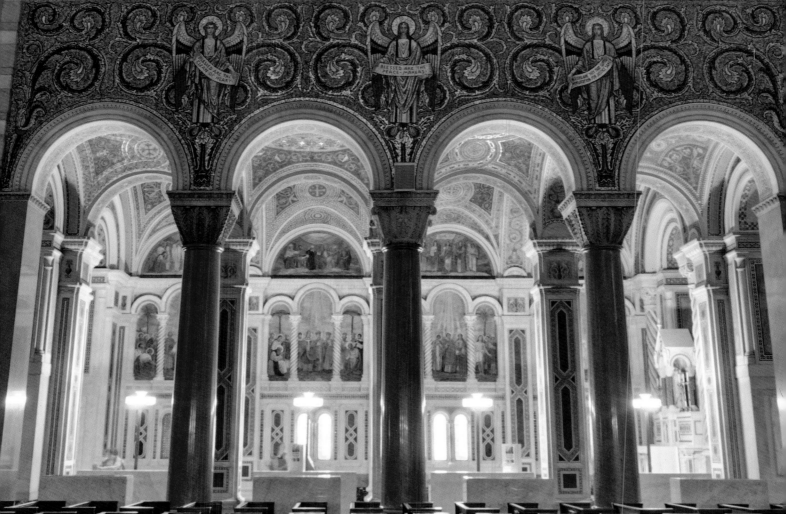

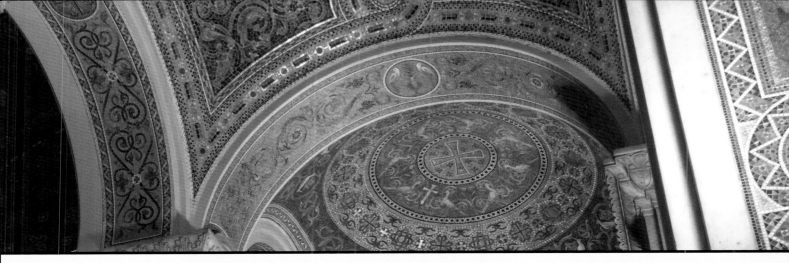

THE NEW CATHEDRAL

 Shortly after he became archbishop in 1903, John J. Glennon set out to build a new cathedral. He chose a design of Byzantine Romanesque, similar to St. Mark's in Venice. Construction began in 1908. Dedication took place on June 29, 1926. The building contains the finest collection of mosaics in the world.

The diamond of mid-America, the observer can look in vain for its rival. Only the cathedral of St. Paul is worthy of consideration, chiefly because of its hilltop position.

Opposite: *Historical mosaics are seen above All Saints Chapel.*

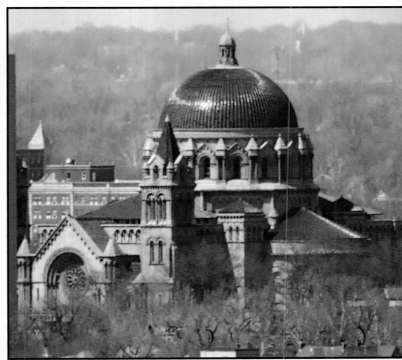

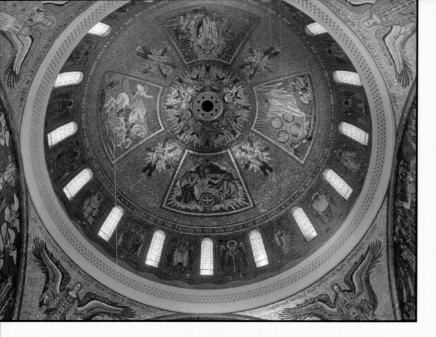

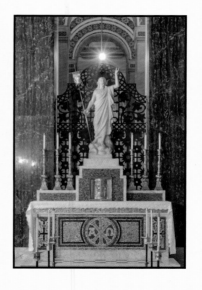

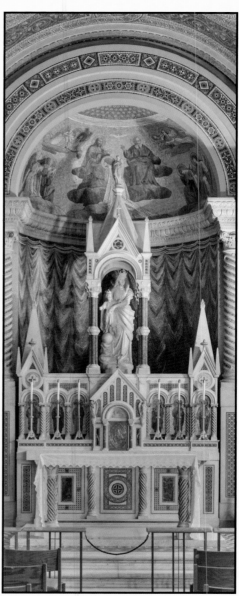

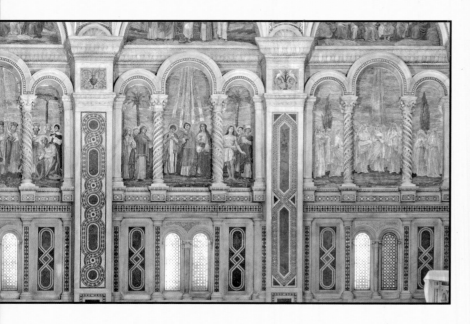

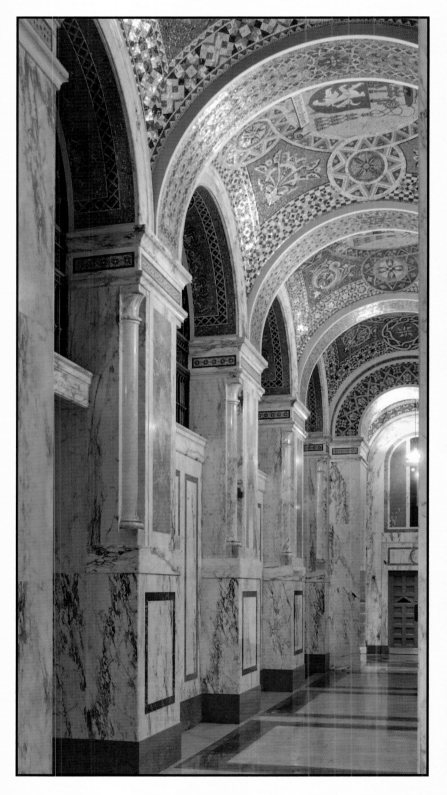

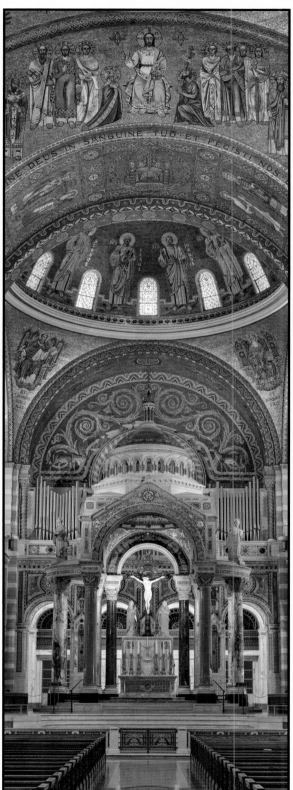

Opposite, Clockwise from Upper Left: *Interior of the main dome; statue of the Resurrected Christ in All Souls Chapel; altar in Our Lady's Chapel; mosaics on the wall of All Saints Chapel; column capital detail.* Above Left: *Ambulatory features mosaics of the coat-of-arms of bishops of St. Louis.*

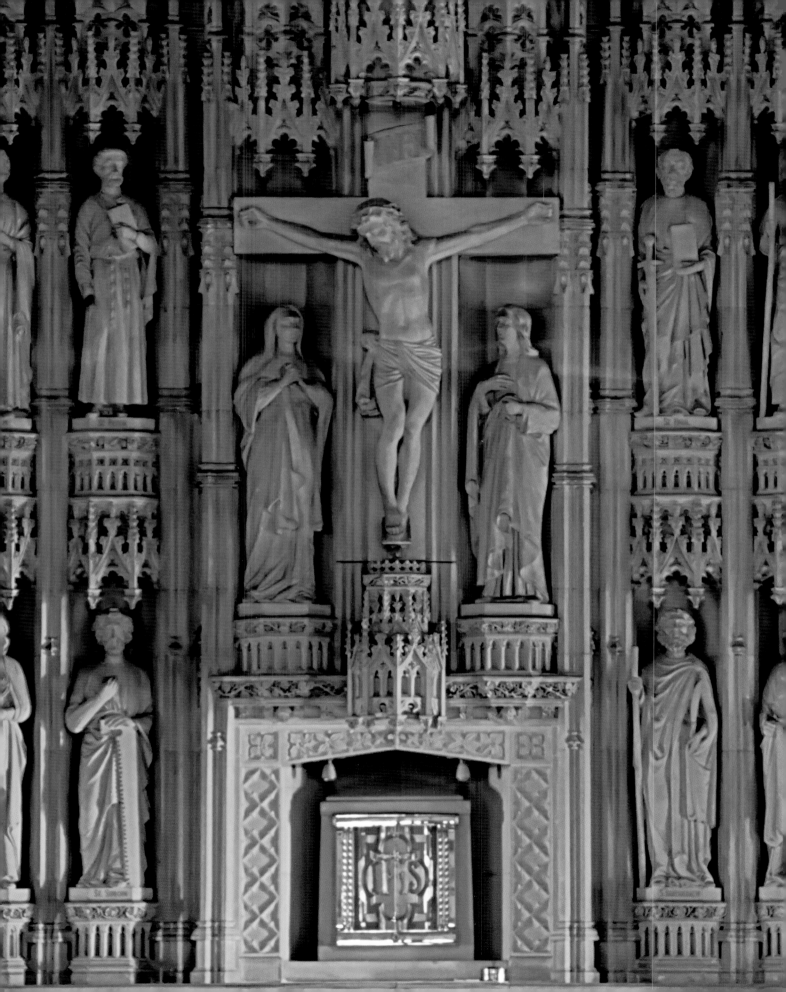

St. Luke the Evangelist

Founded in 1914 by Father Joseph McMahon, the cornerstone was laid for the present church on May 6, 1928, on Bellevue Avenue in the St. Louis suburb of Richmond Heights. It is of English Gothic style.

St. Luke had great appeal for second-generation Irish who moved into houses constructed from materials taken from buildings of the 1904 World's Fair.

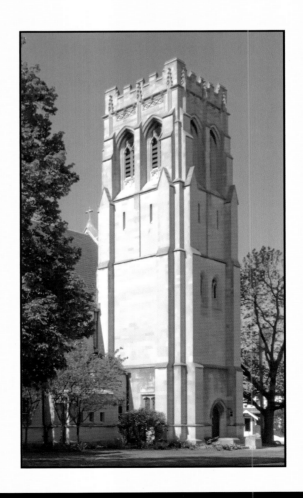

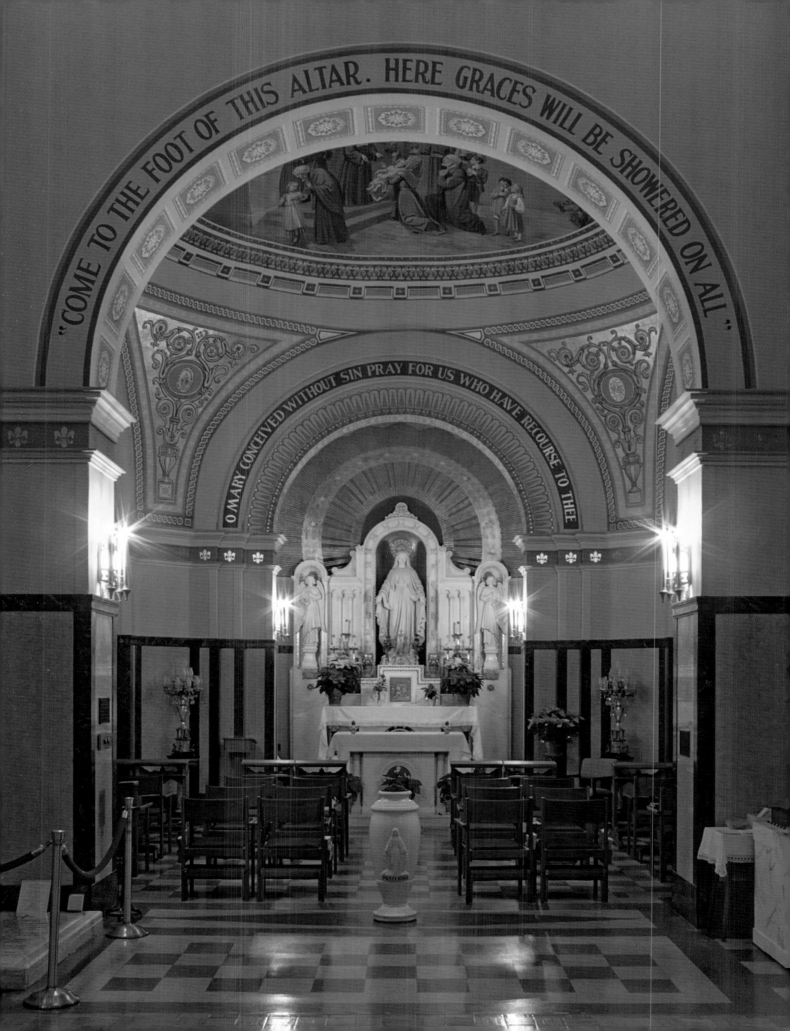

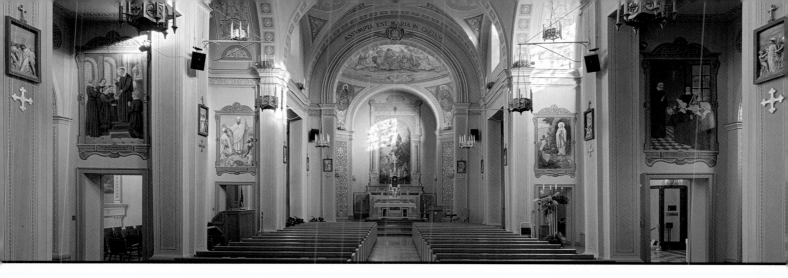

St. Mary's in Perryville is the Mother Church of the Vincentians in America. Erected in 1827 under the superiorship of Bishop Joseph Rosati, St. Mary's followed the plan of the congregation's Mother Church in Rome and differs in appearance from any other church in this book. The shrine of Our Lady of the Miraculous Medal stands nearby.

ST. MARY'S OF THE BARRENS IN PERRYVILLE

Opposite: *National Shrine of Our Lady of the Miraculous Medal.*

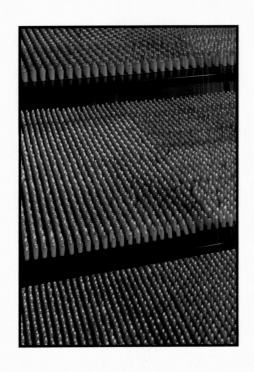

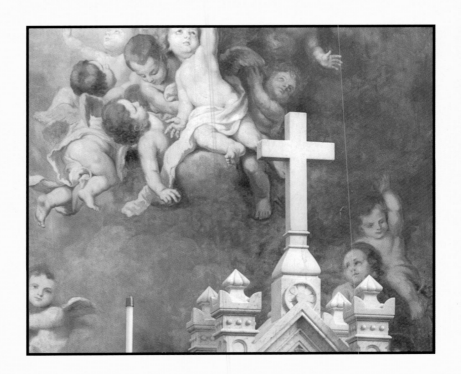

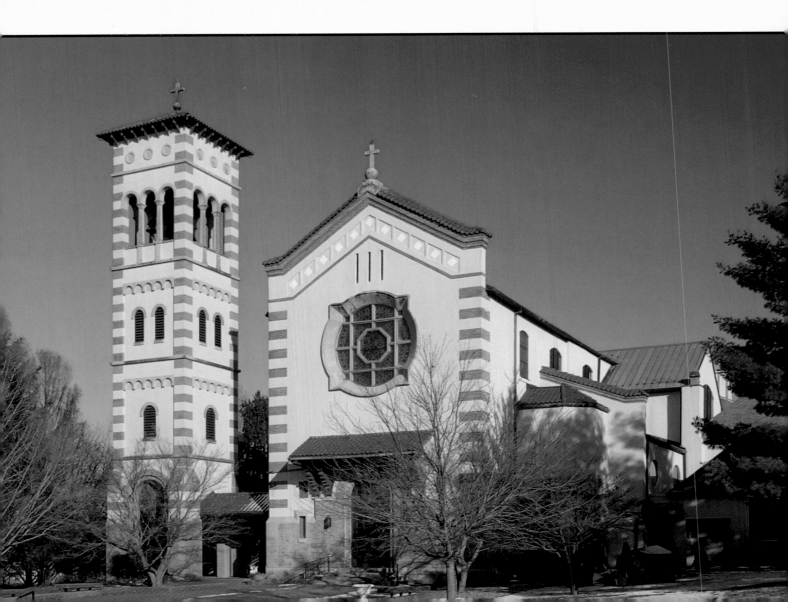

Left and Below:
Outdoor grotto.
Opposite Upper Left:
*Some of the thousands
of lights in the Votive
Light room.*

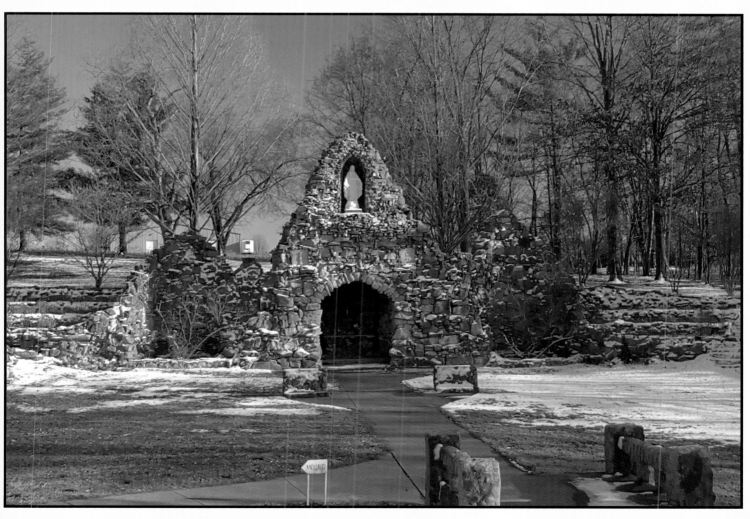

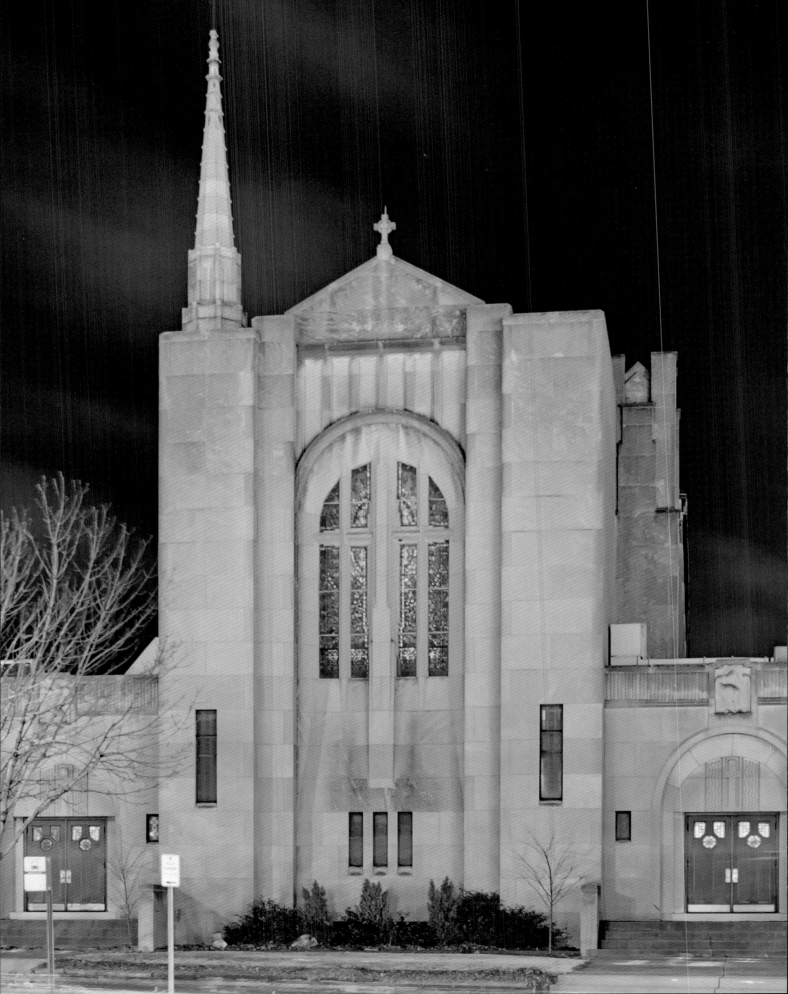

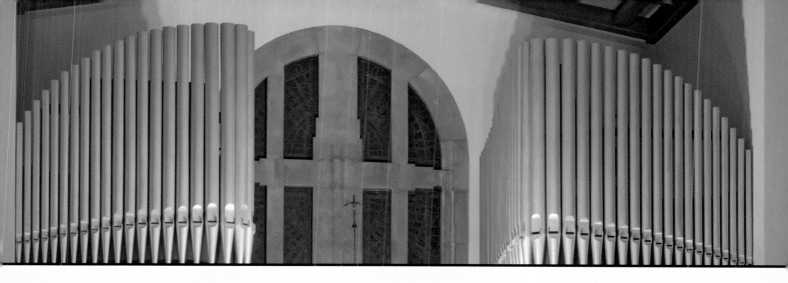

 t. Mary Magdalen, of English Gothic style, occupies the northern half of Our Lady of Sorrows. Its impressive façade faces Kingshighway Boulevard. It has extensive facilities for youth activities, and its parish school long had a place of prominence among elementary schools.

ST. MARY MAGDALEN

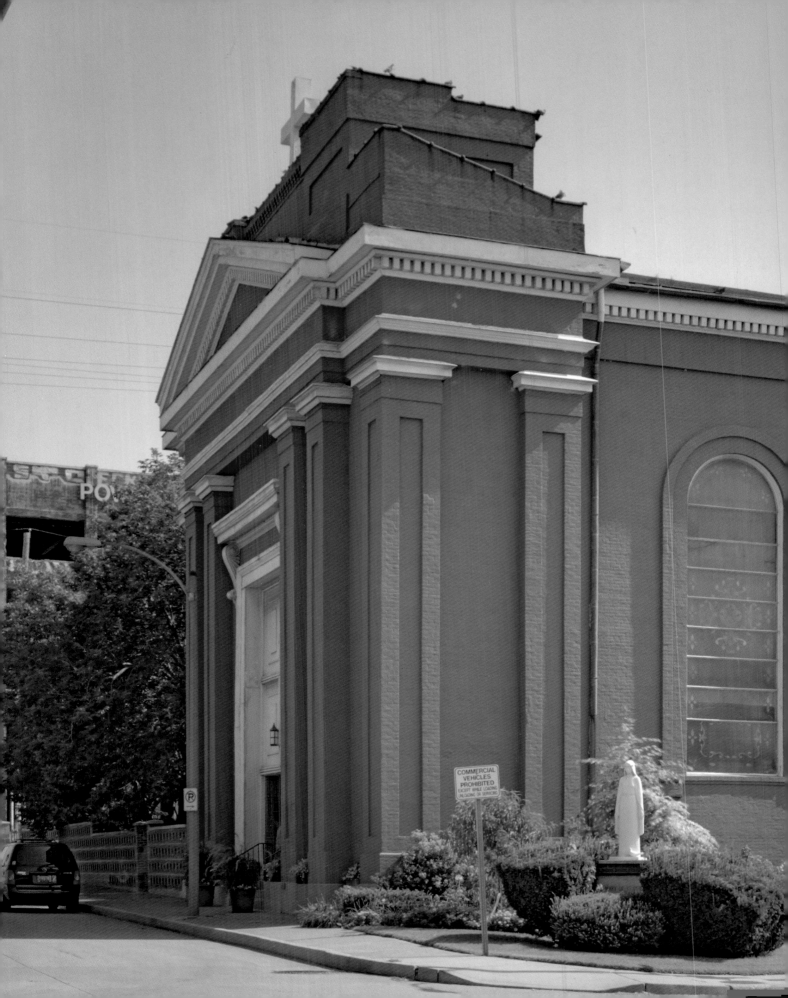

COMMERCIAL
VEHICLES
PROHIBITED
EXCEPT WHILE LOADING
UNLOADING OR SERVICING

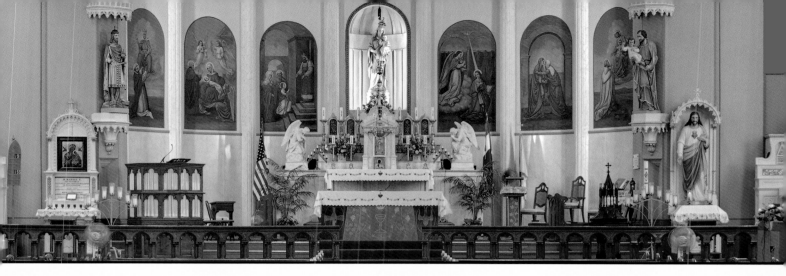

S t. Mary of Victories, a "chapel of ease" for German-speaking immigrants residing in the Cathedral Parish, opened in 1844 at Third and Gratiot streets on land donated by Ann Lucas. The simple brick church of Classical Revival style, with a monumental door, was designed by George I. Barnett and Francis Saler. It was enlarged in 1855 with the addition of the transepts and tower. Prominent German-speaking priests were pastors in the early years. It has served diverse congregations. Most recently Hungarian refugees fleeing communist aggression in the 1960s found a spiritual home here.

ST. MARY
OF VICTORIES

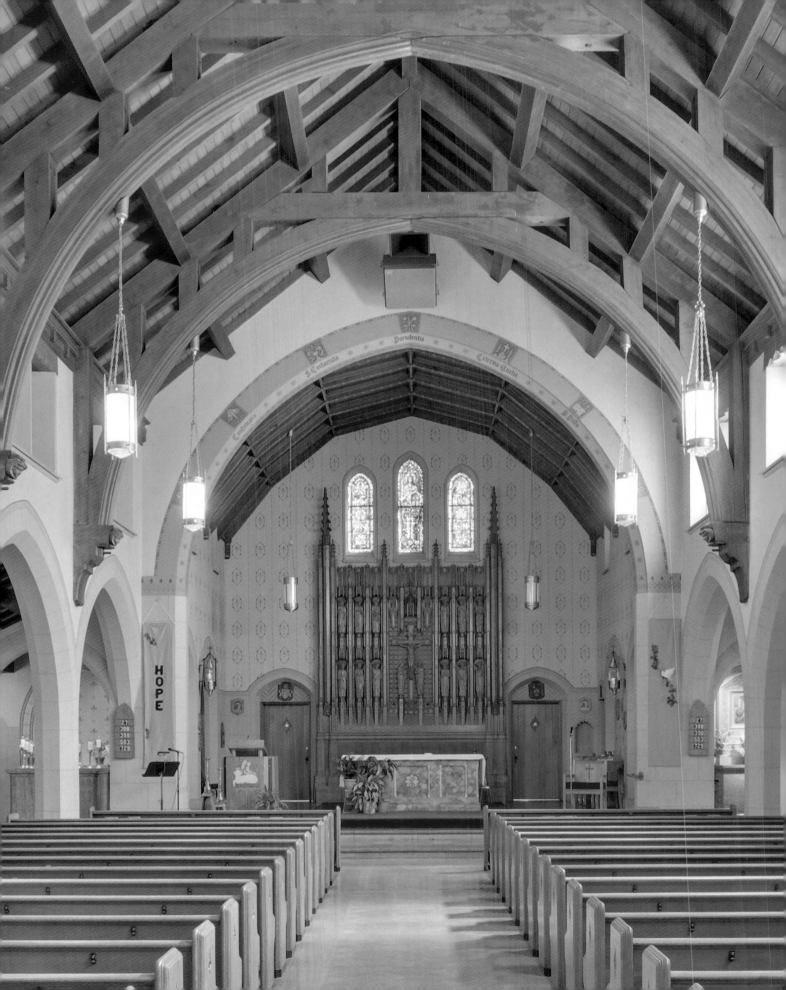

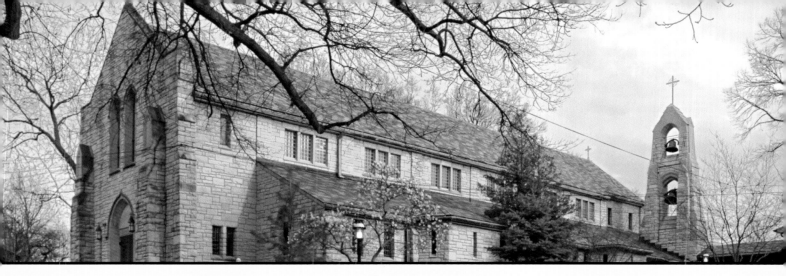

St. Michael the Archangel

 t. Michael the Archangel Parish in Shrewsbury began in the old Murdock stone mansion. Several priests made little progress in organizing the people. Finally, Father Joseph Preuss—the son of the leading lay theologian Edward Preuss, convert and author—succeeded in the task, and he enlarged the original stone mansion. This parish served a mixed group of people between Webster Groves and Southwest St. Louis.

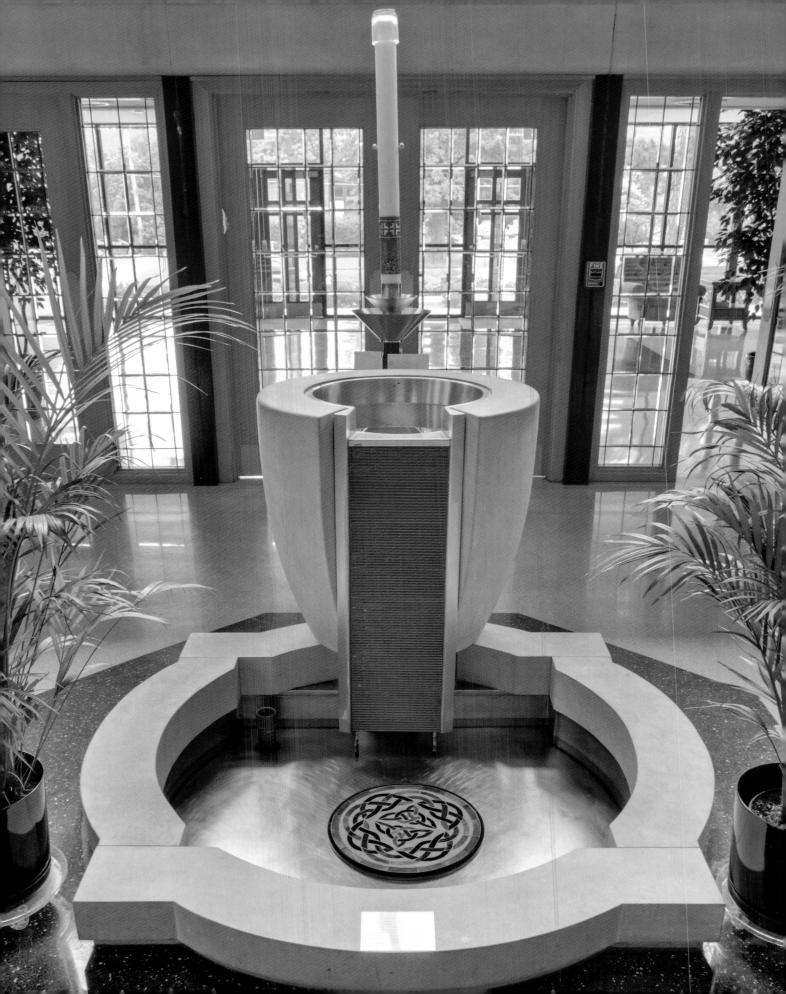

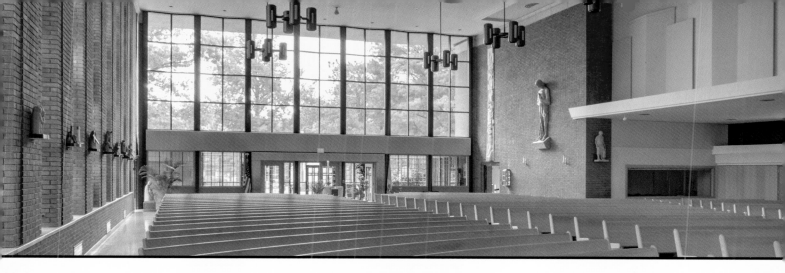

St. Peter Church in Kirkwood was staffed by circuit-riding Jesuits and later by a succession of diocesan priests until it gained stability under the care of Father Eugene Coyle in 1910. Joseph Murphy designed the present church of Postwar Modern style. It was one of two innovative designs encouraged by Archbishop Joseph Ritter during his early years in St. Louis. The other was Resurrection on Meramec Avenue in South St. Louis. The baptistry in both churches catches the visitor's attention.

St. Peter in Kirkwood

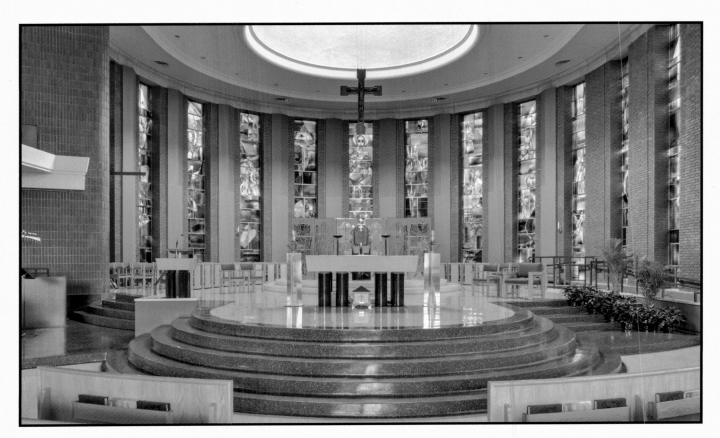

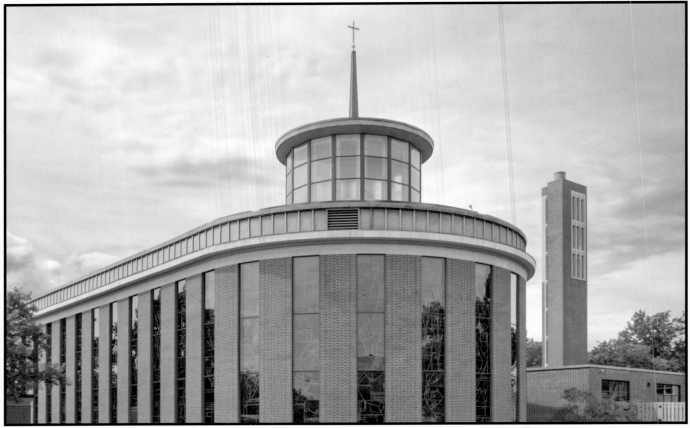

Top: *Former baptistry is shrine to the patrons of the archdiocese, with a statue of St. Louis IX, King of France, and images of St. Rose Philippine Duchesne and St. Vincent de Paul.*

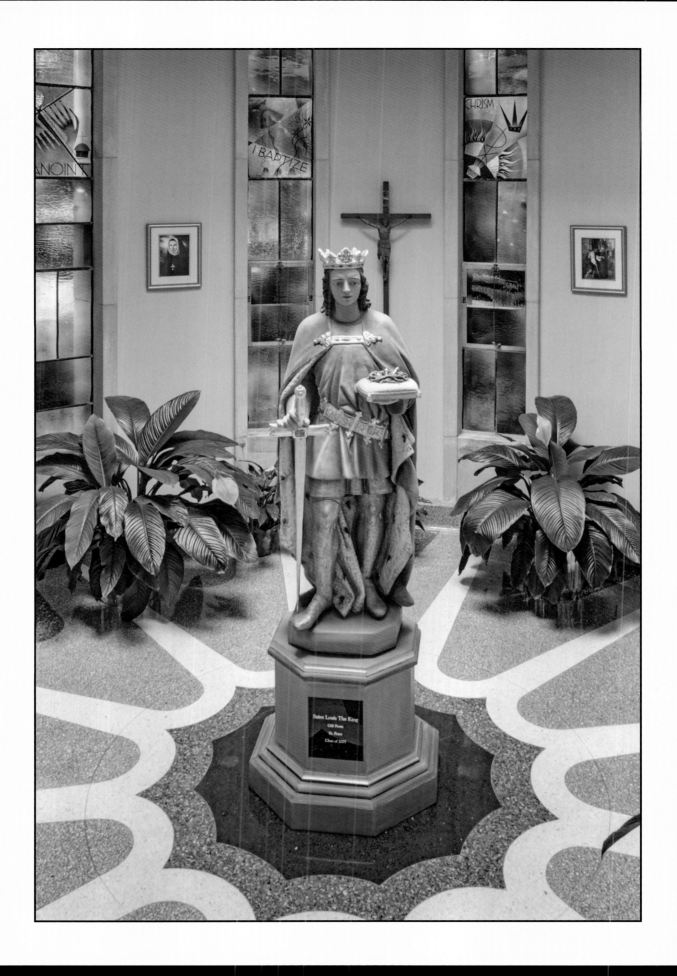

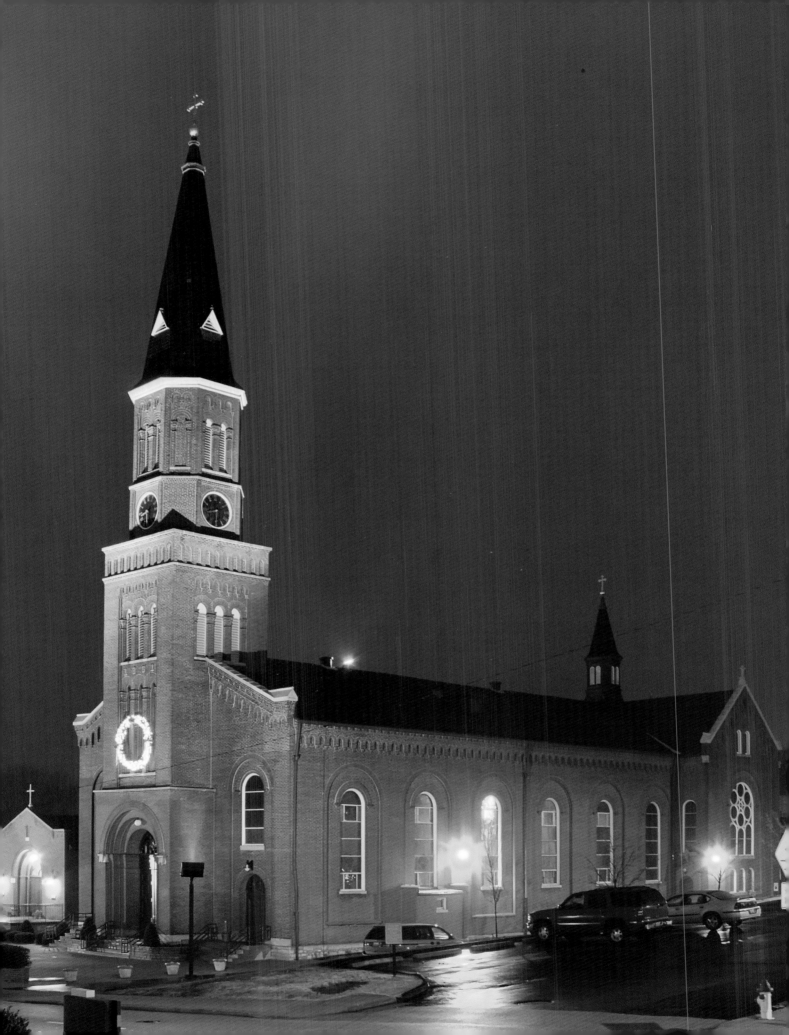

St. Peter
in St. Charles

Father Joseph Moeller was sent to St. Charles to shepherd the growing German immigrant community. In the midst of the Civil War, the parishioners built a brick church of German Gothic design to replace the dilapidating wooden building. The entire structure reflected the immigrant nature of the frugal parishioners who were locating themselves in American society. No resources were wasted in its construction.

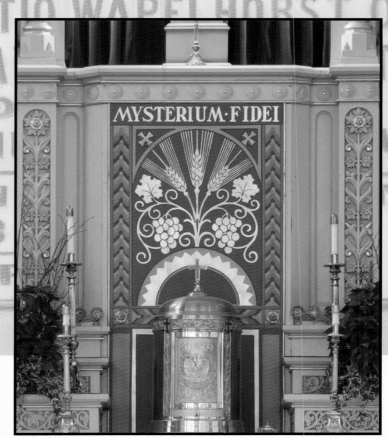

Right: Mysterium Fidei *(the Mystery of Faith) above the tabernacle.* Opposite Left: *A statue of St. Paul the Apostle.* Opposite Right: *Altar of St. Joseph with a painting of St. Rose Philippine Duchesne.*

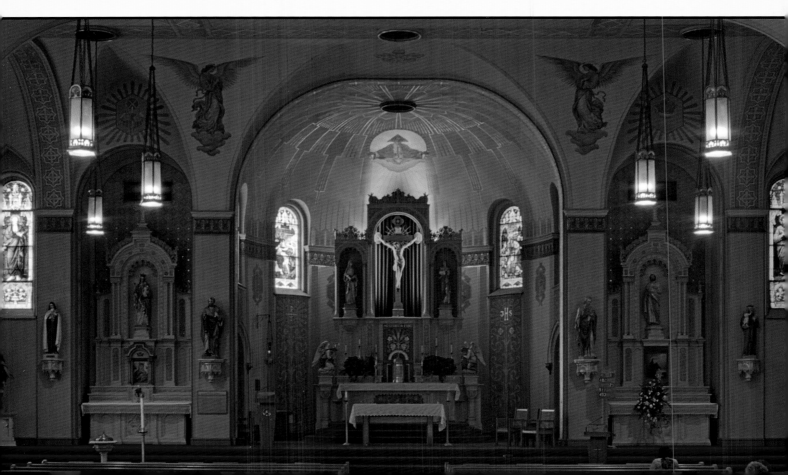

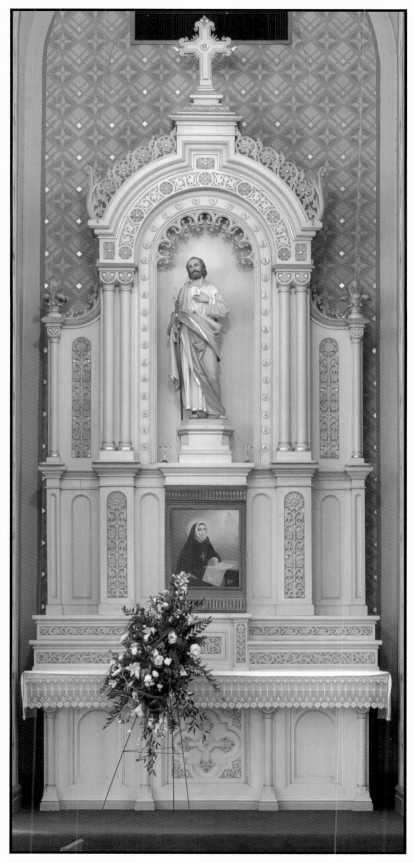

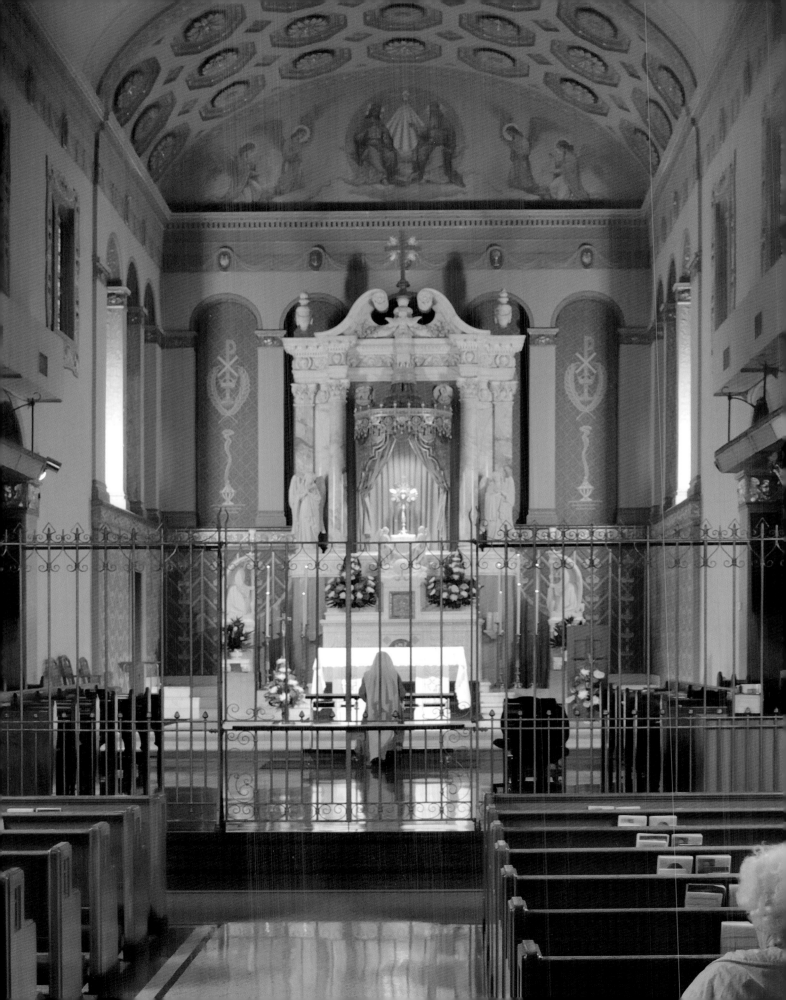

 elmuth and Helmuth designed the Chapel of the Pink Sisters on Adelaide Avenue at Zealand Street, opposite the northeast corner of O'Fallon Park. The location of the chapel at a two-way exit on Interstate 70 in North St. Louis makes it convenient for prospective worshippers to visit and pray.

MT. GRACE CHAPEL (THE CHAPEL OF THE PINK SISTERS)

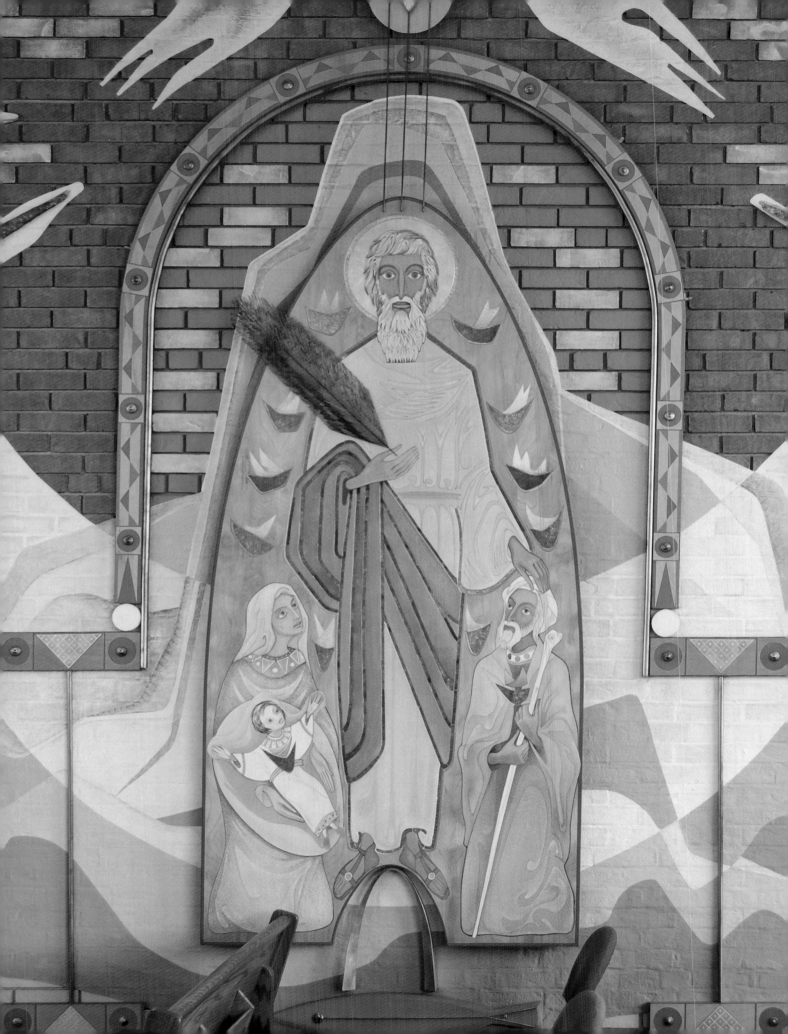

 t. Raymond's was the second Maronite parish in St. Louis. St. Raymond's began in 1913 on LaSalle and Seventh streets. It flourished, and a new church of Maronite style and a spacious hall were built in 1975. While people from neighboring parishes were moving away from their areas of origin, the people of St. Raymond's preserved the integrity of their ancestral area to the admiration of other nationalities. St. Raymond's became a Maronite Cathedral in 2001.

ST. RAYMOND'S CATHEDRAL

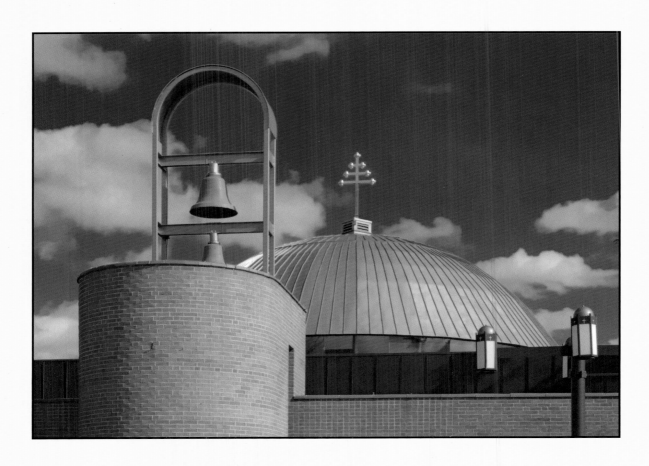

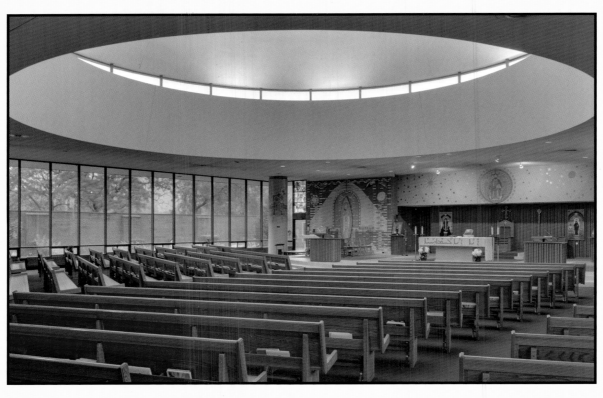

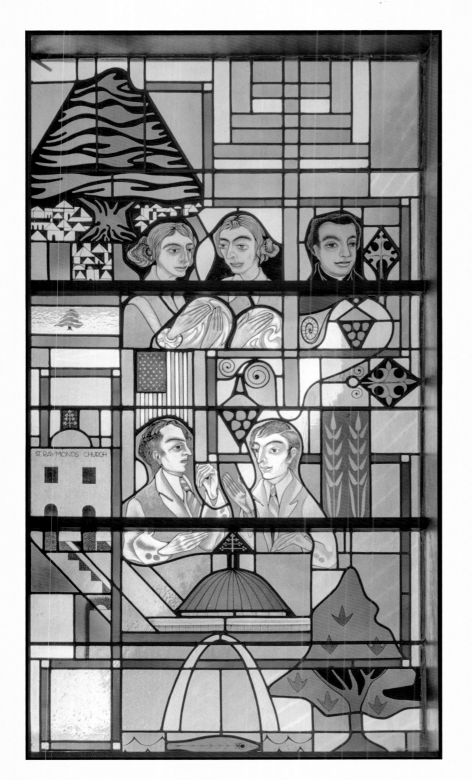

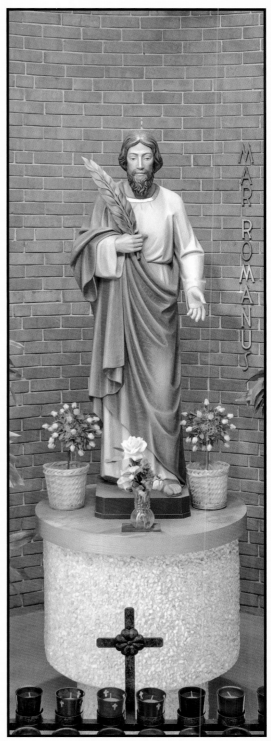

Opposite Top: *A three-armed Maronite cross surmounts the church's dome.* Above Left: *Stained glass window of the history of the church.* Right: *Shrine to Mar Romanus—St. Raymond.*

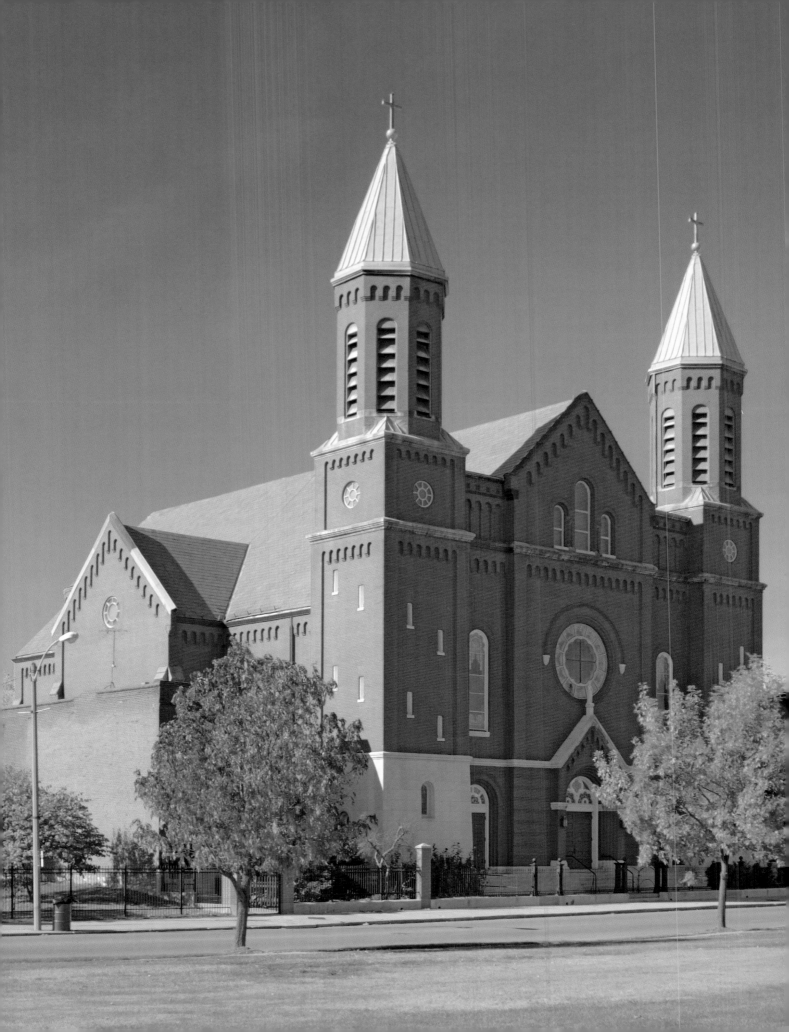

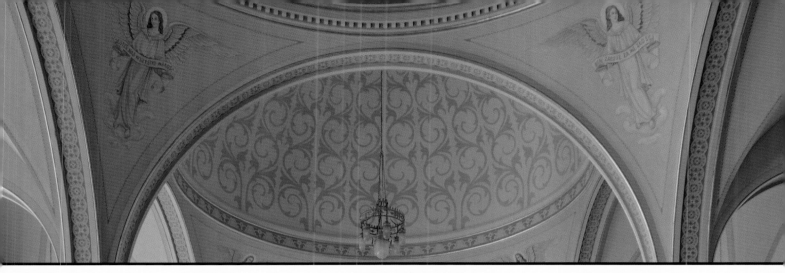

St. Stanislaus Kostka

oadjutor Archbishop
Patrick Ryan approved the
plan of a group of Polish immigrants to
erect a church on the Near North Side.
A local architect, Louis Wessbecker,
designed the church in the form of a
Greek cross. It is the only church still
standing in the area. The other eight gave
way to expanding federal highways or
housing projects.

 The impressive mural behind the main
altar is the work of local artist Jan Stiycka.

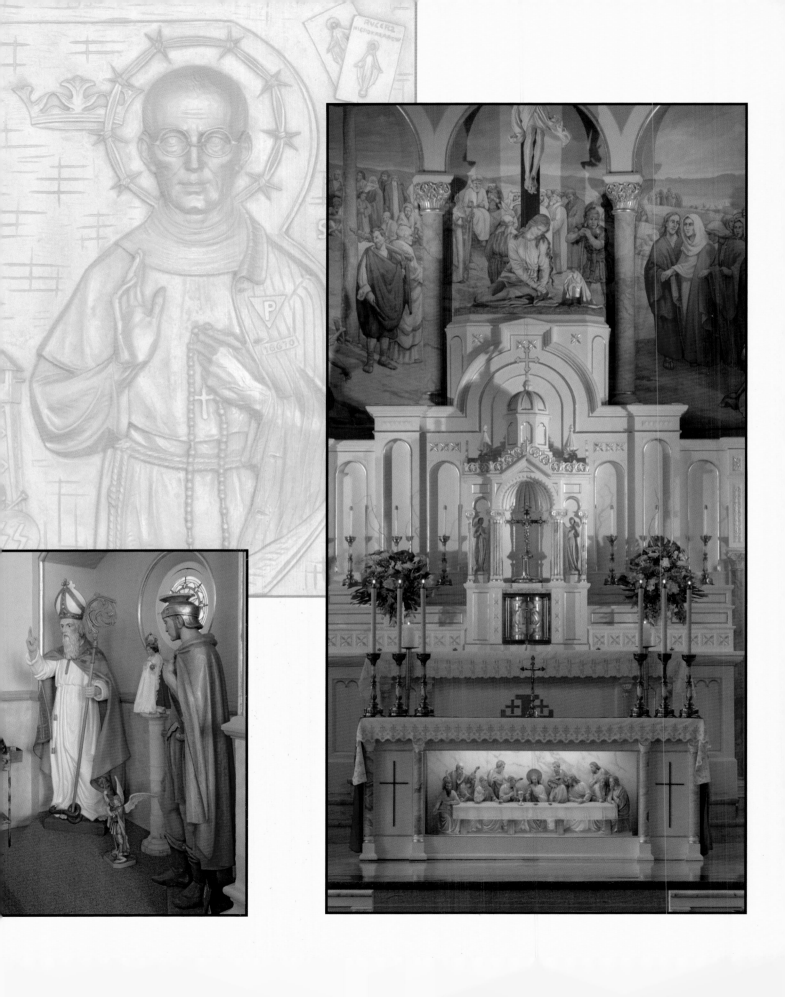

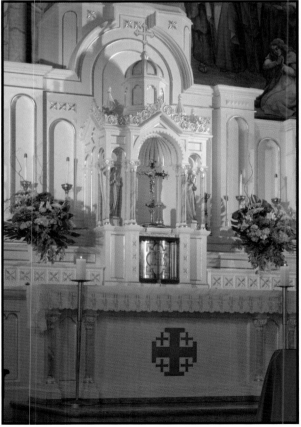

Opposite Top Left: *St. Maximilian Kolbe.* Opposite Bottom Left: *Some of the many statues found in the church.*

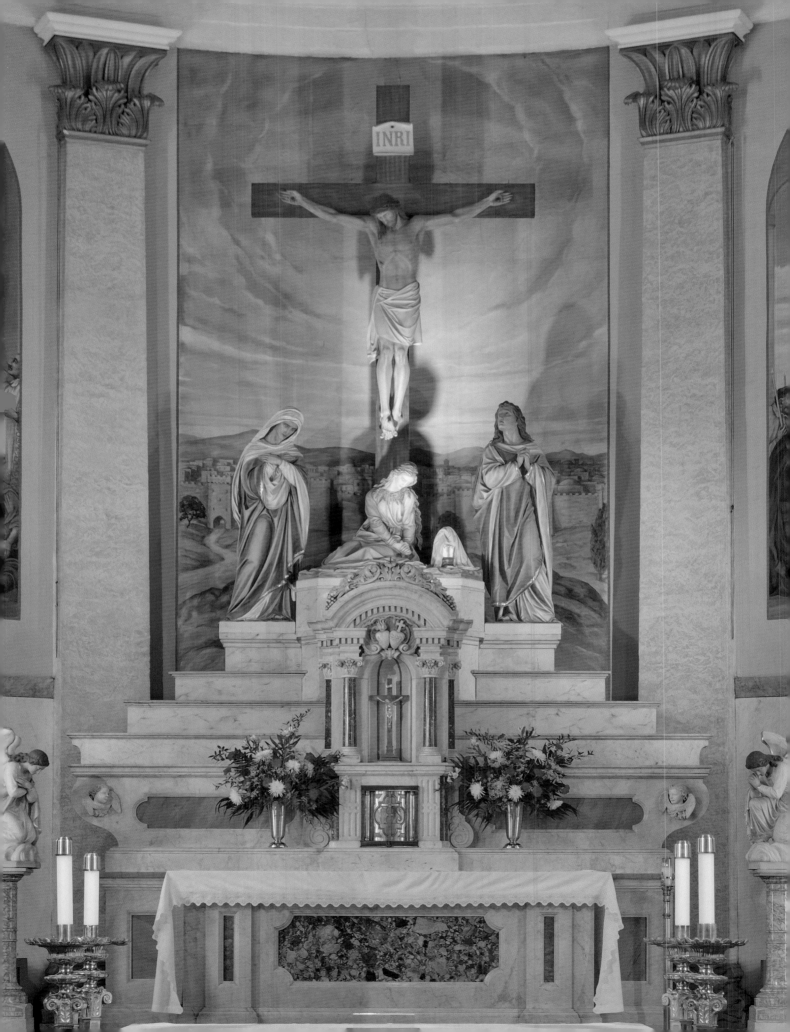

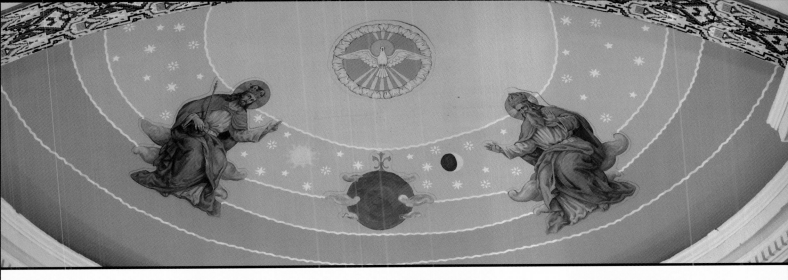

 n 1844, Archbishop Peter Kenrick laid the cornerstone of St. Vincent DePaul, the central church of the Vincentians, who were the pioneer religious congregation of men to locate in St. Louis. One of the architects of this impressive building was Meriwether Lewis Clark, son of the explorer. It featured dual pastorship, one for English-speaking residents, the other for German-speaking residents. It was here where Father John Timon told of the start of the St. Vincent DePaul Society in France and challenged the men of St. Louis to start what became the first unit of the society in America.

ST. VINCENT DEPAUL

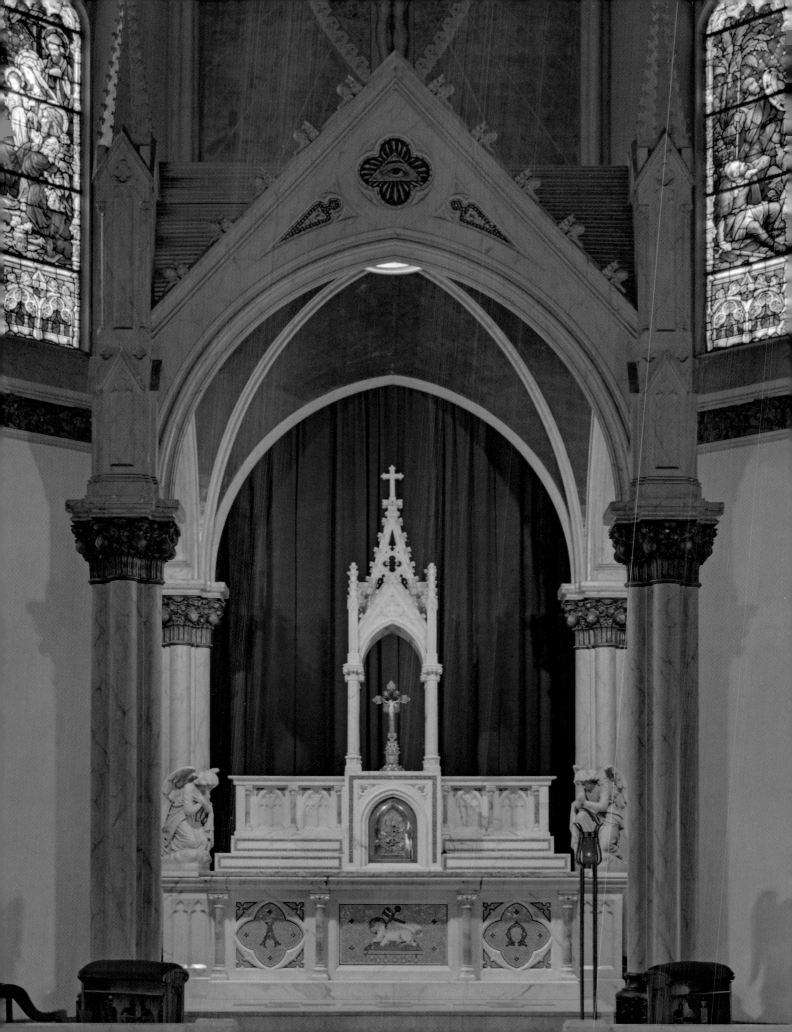

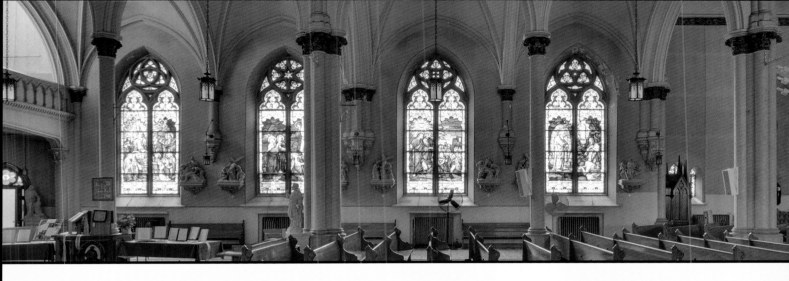

HOLY TRINITY

 oly Trinity, the first church for German-speaking people on the North Side, was opened in the then-suburb of Baden in 1848. A new church of Indiana limestone and of French Gothic style, designed by architect Joseph Conradi, was dedicated by Archbishop John J. Kain in 1899. Damaged in the tornado of 1927, the church was restored. Its twin towers, 215 feet tall, face east and dominate the area.

Many leaders of the second generation of German Catholics in St. Louis grew up in Holy Trinity Parish.

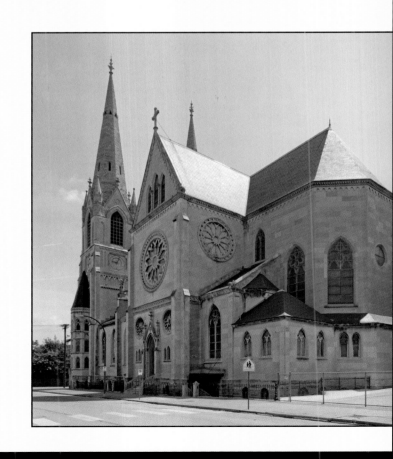

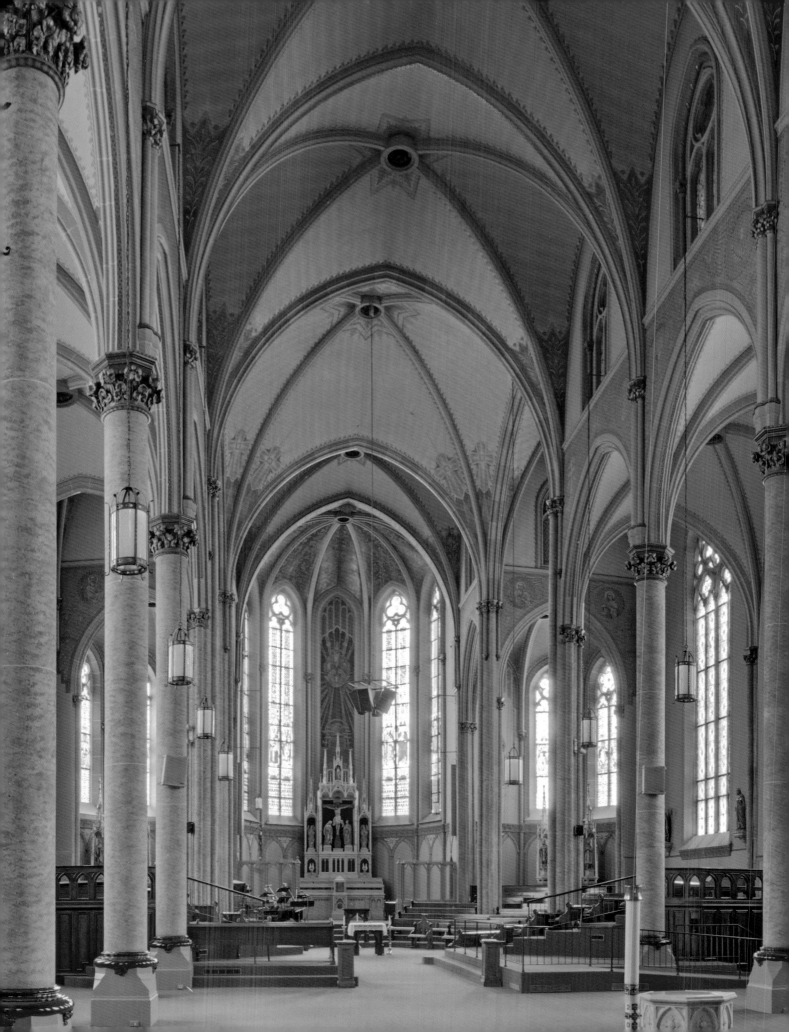

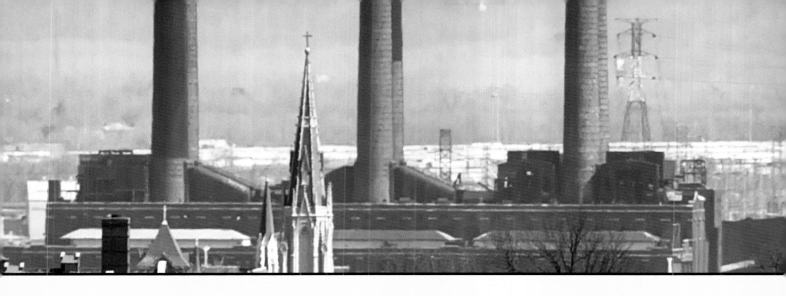

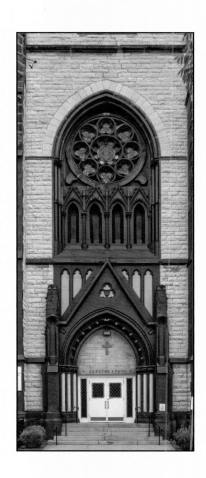

STS. PETER AND PAUL

A church of Norman Gothic style, the masterpiece of architect George Himpler rose on the Near South Side at Eighth and Allen streets. The cornerstone was laid in 1873, and the church was consecrated the next year. The debt was cleared by January 1, 1876. The stained glass is from the Tyrol, the Stations of the Cross from Germany. The church was damaged in the tornado of 1927, but it was restored in its beautiful Gothic style.

When critics chided Father Francis Goller for asking his working-class parishioners to undertake such a magnificent church, he replied: "My people see only drabness all week. I want them to see beauty on Sunday."

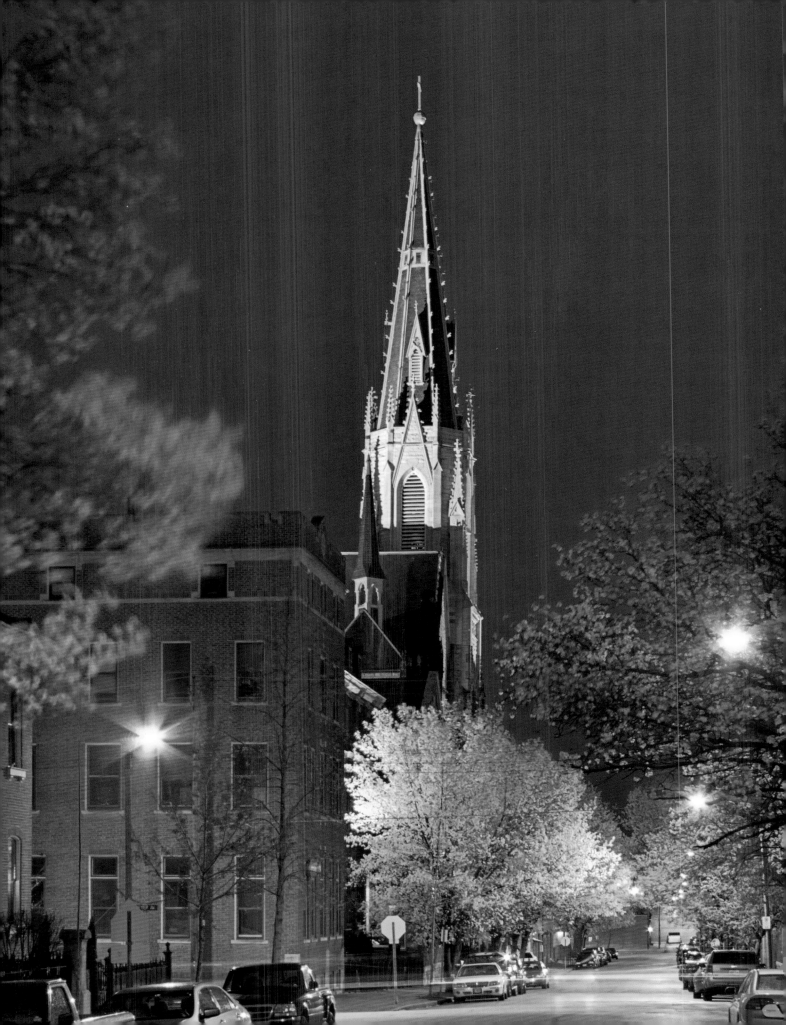